BURBERRY DAYS

BRIAN KITSON

BURBERRY DAYS

*An insider's account of
the clothing business*

*RDT
Sarasota
July 28, 2018*

AUSTIN MACAULEY
PUBLISHERS LTD.

A CIP catalogue record for this title is available from the
British Library.

ISBN: 978-1-78629-144-8 (paperback)
ISBN: 978-1-78629-145-5 (hardback)
ISBN: 978-1-78629-146-2 (eBook)

www.austinmacauley.com

First Published (2016)

Austin Macauley Publishers Ltd.
25 Canada Square
Canary Wharf
London
E14 5LQ

DEDICATION

For Mervyn Unger who got me in
and for Colin Wilson who kept me organised

PUBLISHERS' NOTE

Burberry Days was conceived by the author and publishers as an accurate, if idiosyncratic, account of a key period in Burberry's history and as such it was assumed that the book would be of some interest to Burberry itself. There was even some hope that the company would contribute material from the archive to enhance the book and expand on the author's own collection of Burberry memorabilia. In the end, however, not only did the company decline to offer positive help, but it also refused permission to reproduce any copyright illustrations or other designs. This accounts for the lack of accompanying pictures in the Appendix, 'Burberry, 1910–1940' (page 149), which summarises the author's researches into the origins of the Burberry trench coat.

The terms 'Burberrys' and 'Burberry' are used interchangeably throughout this book. It was known as *Burberrys* during the period the author worked there (1958–80); for the last 15 or so years it has been referred to as *Burberry*.

CONTENTS

FOREWORD
BY COLIN WILSON

I AM happy to write the Foreword to Brian Kitson's *Burberry Days*. Brian was always the master of under-statement. The title of this book could just easily have been 'The Birth of the Burberry Brand', since it charts the history of those twenty-odd years when Burberrys, from nowhere, overtook all its competitors to become the market leader and foremost British clothing brand in the world.

Some today may wish to see things differently and want to question Brian's narrative, but they weren't there and I was. For sixteen of those crucial years I witnessed at first hand and at close quarters how this extraordinary trans-formation was achieved and I easily recognise the people and events that are documented in this book.

Brian was an inspirational leader, and not just on the selling and marketing side which is his focus in this book. His role was pivotal in all aspects of the business.

In the book, he admits that technical issues were 'not my forte'. This is something of an understatement. While

he was a brilliant linguist who spoke several languages, he was positively uncomfortable with technology and disliked getting too involved in organisational matters. I recall once walking into his office to see him struggling unsuccessfully to put together a new two-tier paper tray that had just been delivered for his desk. This story is in many ways a metaphor for our relationship. I am sure Brian had chosen the most elegant paper tray but I found myself having to intervene to put it together for him. Burberrys' – and our – great good fortune was that Brian's and my particular skills complemented each other and that he was more than happy to let me have a relatively free rein when it came to introducing new ways of working. As long as he could see the upside of ideas and innovations, he was happy to embrace them and incorporate them into his overall strategic plan.

As a result, we were among the first to introduce the telex and subsequently fax, to invoice in local currencies and to export garments hanging – indeed, we invented this method of shipping. We introduced the first rather primitive electronic calculators to replace slide rules. We re-engineered factories with state-of-the-art machinery. When we introduced computer systems, traditionally run for the benefit of the accountancy department, the programming had to be marketing-led. Accounting and invoicing would come later. Orders could be processed in the morning, fed into the computer over lunch and fabric orders created and sent to suppliers before close of business. As a result, we were ahead of the competition in placing our fabric orders and the sales force did not waste time selling non-existent cloth. I suspect the process is no faster today than it was forty years ago.

The morale that Brian created meant that people would always go that extra mile. I can recall once being asked to accomplish some well-nigh impossible task, to which I jokingly responded: 'What do you want – blood?' The riposte was: 'Yes, and I generally get it.' I suppose that was true on more than one occasion, but then again, we would all have happily given every last drop.

I have little to add to Brian's narrative except to offer my own understanding of three incidents from the book. The first concerns the purchase of Burberrys by William Peacock, which I heard directly from 'Mr William', as he was known. As Chairman of the company at that time, Peacock had come to realise that Chatham Place, where I worked, possessed what was then state of the art communications equipment – a telex machine – and additionally that I was proficient in its use. He therefore occasionally arranged to come to Chatham Place after normal business hours, when he had need of discretion and a speedy response. During these visits, while waiting for replies, he used to talk to me about a variety of matters. On one occasion he told me about the way he had orchestrated the purchase of Burberrys from the Burberry family.

Peacock explained that in the 1950s many companies had not realized how their balance sheets seriously undervalued their property assets. Burberrys was one such business. He had arranged to purchase the entire business at a price on one day, then the next day sold the factory in Basingstoke for the same money he had paid the Burberry family. In essence he now had a prime property in the West End and a factory in Reading free and unencumbered. In addition, he told me that he had bought so many

businesses this way that he had christened it 'the property five card trick'. Another memorable comment at that time was, 'We only bought it for the property and after that we didn't know what to do with it.'

My second addition is a slightly different memory of the way in which the 'house check' became so important in the Burberry history. While all that Brian says is correct, I suspect that the huge importance that it was later to assume might never have occurred if it had not been for one very fortuitous accident.

Brian and I had been in Paris for a menswear exhibition. It was in September and, one evening after dinner, we were walking back to our hotel in the Rue de l'Arcade, which involved us walking past the Paris Store. We paused to look at the display in the Store windows. Among other things, these featured a lady's raincoat lined with the famous check, which was accessorised with hat, scarf, umbrella and even shoes, similarly in the check.

It has to be remembered that at this time Burberrys was almost entirely a raincoat business, where the colour range was essentially assorted shades of beige, plus a little navy blue. This was not the ideal range of merchandise for the creation of vibrant window displays. As a result, Brian was immediately interested in this somewhat different presentation of a lady's raincoat. He felt this could be a way of persuading wholesale customers to include our rainwear in their own displays and asked me to arrange for photographs to be taken of the Paris window. With the addition of some check accessories, Brian presented the idea at our sales conference later that year. He invited the sales force

to persuade their customers to buy, at a discounted price, a display 'pack' for their own store display.

The proposal was well received and a large number of customers purchased the packs. I am not sure that we ever realised that this promotion would do anything more than promote the sale of our raincoats. We were all, I suspect, taken by surprise when many of our retailers not only sold the raincoats but the display accessories as well and indeed were clamouring to buy more. Within six months I was ordering a regular thousand cashmere scarves a week from Joshua Ellis in Yorkshire, our regular supplier of cashmere and camel textiles.

The Burberry accessory collection had been born.

My third addition relates to the decision to start doing photoshoots in historic British locations. This was largely the accidental contribution of Peter Haccou, a large extrovert Dutchman who was not afraid to speak his mind. While he was one of our agents in Germany, during the war he had been a member of the Dutch resistance. On many levels he was not a man to be ignored or taken lightly.

During one sales conference, I guess in the early 1970s, the advertising agency presented their photography for the following season, which involved, in Brian's words, 'stiffly posed unsmiling models'. What made matters worse was that the backdrop was rather brutal concrete architecture. From memory, I seem to recall, it was the then relatively new Hayward Gallery on the South Bank.

The reception was quiet and unenthusiastic, but it was Peter Haccou who stood up and asked, in so many words, why, when England had such beautiful countryside and

such historic architecture, had such an ugly location been chosen. I felt he expressed the view of the entire overseas sales force.

Consciously or unconsciously, I have always believed that Brian absorbed Peter's thoughts and that this intervention marked the turning point in Burberry advertising, since the next season the Lichfield campaign began. Needless to say, this was rapturously received at the next sales conference.

It should be remembered that, while in the 21st century such photography may seem rather clichéd, in the early seventies the use of British heritage in people and places had never been tried and was entirely original.

I wonder whether *Burberry Years* should become required reading for the present Burberry management in these uncertain times for the label. While not wishing to minimise the achievements of the business, the narrow concentration on China over the past few years, at the expense of other markets, has left Burberrys exposed. Europe, Japan and the USA, where tastes have radically changed, seem to have taken a back seat.

It is a similar picture when it comes to advertising. Without the logo and the check, nine out of ten people would be unable to identify the brand that was being promoted. Back in the 1970s, it was a source of irritation to me when competitors began to realise the impact of the Lichfield campaign and tried to emulate it. Brian's reaction was: 'Don't worry, all they're doing is advertising Burberrys.'

Burberrys was always a product rather a designer brand. There is a huge distinction. The pursuit of style over substance may have short- or even medium-term financial

benefits, but it is the easy option and must inevitably lead to Burberrys becoming just another designer brand in an already overcrowded market.

Of course the circumstances are different to those in which we found ourselves in the 1960s and 1970s but in many ways Brian Kitson's enduring legacy is that, in the middle of the twentieth century, when the business had lost its way, he recognised and reinvented those values that guided the original Burberry concept of the nineteenth century and found a way to use them to drive the business to a new level.

For those of us that love the brand and spent a good deal of our lives working for its success, this book has some pointers to the way forward. I can only hope that, somewhere, there is another Brian Kitson who has the vision and singleness of purpose to do it all again in the 21st century, and that there will be those around him who will enjoy the ride as much as I did.

1
THE RECRUIT

NEW YEAR, nineteen-fifty-eight: I had recently left the Army where I had been posted for my National Service to the War Office in Whitehall. I decided to stay on in London to enjoy my new-found freedom with no special plans for the future. Not having a telephone in my rented room, I received a letter from an Army friend informing me that a company called Burberrys were looking for someone with foreign languages ability and he knew this had been my degree course.

I had met Mervyn Unger at the Army Interpreter School where we were studying Russian. We were then both posted to London to join the Russian Section of Military Intelligence. Mervyn lived at Mile End and I stayed at his family home until I found a flat in Earl's Court to share with another soldier.

As demobilization approached, Mervyn announced he had a job to go to. He had an uncle working at the Polikoff suit manufacturer in Hackney. The business had just been bought by GUS and the Chairman, Isaac Wolfson, came

with an entourage to inspect his purchase. Although the uncle's job was to sweep up and collect the off cuts from the cutting tables, it did not deter him from stepping in front of Wolfson and announcing:

'My nephew's been to Cambridge. You should find a job for a boy like that.'

Wolfson turned to one of the entourage and told him to give the uncle a business card.

'Tell your nephew to call this number.'

It turned out to be Burberrys and eventually led to my own association with a company I had never heard of. Mervyn had soon moved on from Burberrys and was now working for the impressive-sounding Great Universal Stores (another company I had never heard of), which had recently taken over Burberrys. He had been asked to find and interview suitably qualified candidates to fill the position he had just left. He kindly decided I should be the one and so began the first real job I had ever had.

I found my way to the imposing Haymarket store where, since I was the sole candidate, the interview was brief. Mervyn explained that the organisation was in an unsettled condition in the aftermath of the takeover and the future of the company was not entirely clear. The few customers wishing to order the product were mainly not English speakers, hence the need for an interpreter.

I took his friendly hint that this might not be a long-term career, but I accepted assuming it would be yet another of the temporary jobs I took from time to time just to stay on in London and put off a return to the north of England.

And so I started the very next Monday as the 'Wholesale Showroom Assistant'. The salary was £12 a week, hours Monday to Friday 9.00 to 5.30.

The showroom was on the second floor overlooking the Haymarket. It was reached either by a dark oak staircase or a small lift. It was furnished in a rather faded Louis XVI style and I had a small desk near the entrance ready to greet any visitors. These turned out to be rare and were indeed mainly foreign. The main question I had to answer was if the company was still in business. The elderly show-room manager was Frank Davis who did little to explain the merchandise on offer. The lack of organization was explained by the regular changeover of 'executives' follow-ing the departure of the previous management, including the Chairman Murray Burberry. His office was being cleared out for the next, probably short-lived, occupant.

He was a Mr Chapman and was indeed short-lived. With little to do, I was gradually becoming a kind of odd job man. One day, I was summoned to find in the corridor outside the Chairman's office a large wheeled skip. It had been completely filled to the brim with all kinds of books and papers.

'Take that stuff down to the boiler room in the base-ment and burn it in the furnace.'

I could see the skip contained numerous illustrated catalogues mixed amongst other piles of old correspond-ence. Frank had still made no effort to teach me about the merchandise so I saw an opportunity to educate myself. I wheeled the skip into an empty office to sort through the contents, which seemed to date back over about fifty years. I removed all the books, leaflets and photos I could find and put them away. I assumed the remaining contents

3

of the skip were the Chairman's old correspondence and company records. The thought that this might be the history of one of Britain's most famous companies never crossed my newly recruited mind. I did as I was told and took the skip with its remaining contents down to the boiler room and watched as they were fed into the furnace.

For much of what I later discovered about the history of Burberrys I had to rely on hearsay during many discussions with the older members of staff. They all held the family in great affection despite the fact that the company had failed to negotiate any pension entitlements for their loyal employees. Fortunately, and to the credit of GUS, these obligations were fulfilled albeit on ex-gratia basis.

It soon became clear that one reason for the state of confusion was the recent closing down of the extensive premises at 15-16-17 Golden Square just behind Regent Street. This had been the home of the Wholesale and Export Division of which I was now, it seemed, the most junior member. The many functions from Golden Square were in the process of being hastily redistributed, including the staff, around a variety of locations from Wardour Street, Hackney and Reading.

It took me some time to discover what had gone where.

The rumour mill worked overtime with worrying stories for the older staff that the wholesale and manufacturing business would be closed down, leaving just the two retail stores in Haymarket and Paris. The Burberry name would then be utilized for a more upmarket GUS mail order catalogue.

By chance, I found my very own private source of information. One member of the Burberry family had been persuaded (paid) to remain, but he appeared to have no

function other than lending his name to the company letterhead.

The last of the Burberrys – or a story of the two Brians

I had noticed an elegantly dressed gentleman of perhaps about sixty years.

He seldom came into the showroom and spoke to no-one. He reminded me for some odd reason of the actor Herbert Marshall. It was early summer and there was little for me to do in the showroom. One morning Frank said to me:

'Mr Brian would like his copy of *The Times* to his office.'

And so I learned that this was Brian Burberry, the sole remaining family member in the business. It was a very nice office but, apart from his empty coffee cup, totally devoid of any papers or personal items. He asked me who I was and what I was doing. He appeared to take a liking to me and I wondered if my being a Cambridge man might have just qualified me as a possible gentleman. Also, I was not one of those 'pushy Jews' from GUS Head Office he so very clearly disliked.

And moreover, I was also a Brian!

He took to inviting me to his office from time to time in the late morning where I provided an audience for his reminiscences and helped to pass the time until he left for what usually seemed a very good lunch around noon. I pictured him having a drink at his club before lunch until I saw him return around three o'clock, his face looking slightly flushed.

He liked to stand in the showroom and gaze silently out over Haymarket while smoking one of his favourite Gold Flake cigarettes. I watched the ash burn down almost to his fingers and wanted to warn him as I wondered what his thoughts might be.

'Well Kitson, I must be off now to catch my train. I'll see you tomorrow.'

Again, I pictured him in his Burberry heading off to somewhere probably in the stockbroker belt. He was under no illusion about his role in the company. He had no visitors, nobody sought his opinion and all he had to do was see his name appearing on the letterhead of a company his family no longer owned.

And then, one day, he did not turn up at the office. No announcement was made.

He just silently disappeared, taking his name with him. I had come to like him and was sorry at his departure.

Fortunately for me, I had received during his brief stay several very valuable tutorials. He had had a considerable involvement in the Burberry cotton mill at Farnsworth near Manchester and possessed great expert knowledge of the cotton trade. He considered that Burberry fabric had been the foundation stone of the company. It was produced in a large, full process mill starting from the raw cotton, to spinning, weaving, dyeing, finishing and proofing a wide variety of fine count fabric qualities. Early in the twentieth century the company had attempted to register a trademark for their fabric by calling it 'Gaberdine', but the application was refused, presumably as being too similar to the established generic term of gabardine.

The secret of the weather protection was in the proofing process of the yarn before weaving and then a second

proofing of the woven fabric utilising a wax-based fluid to cause rain to run off 'like water off a duck's back'. The tightly woven fine yarn count twill weave fabrics were wind resistant and of a quality difficult to find in these more modern times. The fabrics would require some re-proofing from time to time, a service which the company was happy to offer and which was utilised regularly by members of the Royal Family.

When the fabric was cut to produce a raincoat, the sewn seams were the likeliest place for water to penetrate. Burberry then devised a one-piece raglan sleeve construction to eliminate the most exposed seam running over the top of the shoulder. This produced a generously cut, easy-fitting garment with an open stitched hem to encourage the shedding of rain as opposed to a close-fitting coat where the body heat would encourage water penetration. This style became known as the Model no. 1 'Walking' Burberry dating from the late nineteenth century – and 'Burberry' entered the dictionary as the generic term for a raincoat.

It sounded convincing and the idea reminded me of my army poncho cape, but I would not have known any better without this little lecture. The promotion of Burberry as primarily a technical innovation over and above any ephemeral fashion seemed to make sense, albeit to my then commercially untutored self.

As Mr Burberry quietly went to and fro from his office as if wishing not to be seen, I felt he might be still living in the happier days of the nineteen-thirties before the war. His family had provided the protective clothing for both Scott and Shackleton on their expeditions of discovery to the Antarctic. The unheated weatherproofed flying suits

of the two airmen in the open cockpit of an ex-RAF aeroplane making the first transatlantic flight in 1919 were also by Burberrys. The company held warrants from the Royal Family and their customers came from the upper levels of society both at home and abroad.

Brian Burberry was clearly very proud of the company's history, but the drab post-war world brought socialism and austerity to a largely bankrupt country. Any return to the old level of trading was going to take a very long time, which was something the company did not have. He may have felt some shame at the down-market mail order catalogue company into whose hands Burberrys, with all its one hundred years' illustrious history, had so quickly fallen. I wanted to know more about the reasons, but thought it better not to ask. He never mentioned financial matters, nor did he offer any explanation for how the company ended in such very serious difficulties.

I could only speculate, but with the benefit of hindsight, I imagine that financial mismanagement must have played its part, perhaps with an overhead too large for the level of sales in post-war conditions. Crucially, however, Burberrys failed to perceive the drastic solutions about to be carried out by GUS, and which might have saved the company. Certainly, their financial advisers could not have been the shrewdest, as it was said that around a million pounds of debt could not be covered. Such a sum was quite unimaginable in the nineteen-fifties for a clothing business, however famous. A massive bankruptcy was inevitable without a sale to the sole cash bidder – Isaac Wolfson.

Nevertheless, Mr Burberry seemed to have appreciated an attentive audience, even if it was only just one very

junior employee. I had learned something and was glad to have known him, albeit briefly.

2
SO WHAT HAPPENS NOW?

I SAAC WOLFSON was an Orthodox Jew from Glasgow at the furthest possible remove from the patrician Burberrys, so accustomed to serving royalty and the highest levels of society, even though they too had made a very modest start in Basingstoke a hundred years earlier. Before the war, Wolfson had acquired a small general merchandise company in Glasgow called Great Universal Stores. After the war he set up his office in London and had developed the business into mail order catalogues and door-to-door salesmen. The mail order companies recruited many local agents to obtain orders from the catalogues on which the agents would receive a small commission. Credit was made available 'on easy terms'.

A parallel business was the visiting salesmen each in his small green van loaded with merchandise. This was mainly for working class areas such as the East End of London and the customers were typically housewives who were able to pay an agreed sum every week to the salesman on his regular call. He would deliver the goods and collect

money, often agreeing his own 'terms'. The object was to keep a very regular supply of merchandise to the customer and collect their weekly payments. These salesmen were known as 'Tallymen'.

The Wolfson businesses offered inexpensive merchandise, but what they were really selling was credit while maintaining a healthy cash flow for themselves.

In the difficult post-war years, these companies enjoyed a considerable success. Rationing of not just food but also many items of everyday life, including some clothing, continued until 1954. Strict foreign exchange control, especially of US dollars, led to shortages of many essential raw materials. Industry was slow to change over from a wartime economy to the different demands of the peace. London, at the centre of the economy, was still a severely bomb-damaged city and as a consequence property values were at very low levels. They appeared as such in company balance sheets and Wolfson guessed that reconstruction must soon begin and property values would escalate, especially in the West End.

The Burberry balance sheet showed ownership of two such undervalued prime freeholds in Haymarket and Golden Square.

Wolfson decided to make a bid for the hugely indebted company, finding its assets much more interesting than its commercial operation. But there was no company within GUS in any way resembling a Burberry type of business and consequently there was no-one with the necessary expertise.

Wolfson's personal reputation was not of the highest at this time. There had been (unproven) rumours of his involvement in the improper soliciting of government

licenses. Prosecutions were not uncommon in an over-regulated society struggling to emerge from wartime-era controls. Wolfson guessed the likely attitude of the Burberry directors and decided not to make an approach in person. Instead, he sent as negotiator the only non-Jewish main board director – William Peacock. He was a close associate of Wolfson from the very early days and had just returned from running the GUS business in South Africa. He could provide the funds to complete a purchase immediately. It was by now the only practical offer on the table and the alternative for the Burberrys would be a shameful bankruptcy. The company was sold for more or less the value of the debt which was paid off not long afterwards as the freehold property values rose as predicted.

Haymarket was sold to the Prudential Insurance Company and then leased back to Burberry. Golden Square, the original location of the Wholesale and Export Division, had also been sold. Its functions were split up and transferred to other locations – Wardour Street Soho, Chatham Place Hackney and the Reading raincoat factory. It was just at this confused time that I joined the scattered staff of the former Golden Square Wholesale Division, but I was sent to the Haymarket showroom.

Brian Burberry had sufficiently stimulated my interest in the company for me to stay a while to see what would happen rather than make an early exit. I was just twenty-four and few of the surviving Wholesale staff seemed very much under sixty. I imagined they were just waiting for retirement, but I started asking about their lives and experiences, subjects older people like to talk about. They seemed to accept me as genuinely interested in their work and I began to understand how the company had operated

with such success in the past and I wondered about its chances of a future revival.

Adding my own observations to their anecdotes and reminiscences provides much of the material for the following description of Burberry post GUS as it looked in 1958.

18 Haymarket

I worked in the Wholesale Showroom on the second floor. On the third and top floor was to be found Mr Rolfe and the 'Counting House'. In keeping with the Dickensian terminology, every individual sale was entered by hand in large ledgers and Mr Rolfe, small and industrious, wore celluloid cuff covers to keep the ink off his shirt. There was a curious system of vacuum-operated tubes connecting to various points on the sales floors below to deal with cash and receipts, all handled very smartly by several ladies of a certain age.

On entering the store from the street, customers would be greeted by a formally dressed gentleman – black jacket, pinstripe trousers and bow tie – standing at a lectern. After discussing the customer's requirements, he would conduct him to and introduce the appropriate sales assistant. He had the same function as the head waiter in a very formal restaurant and looked very much like Mr Pickwick. Ladies were directed to a pleasant softly furnished salon on the first floor.

On the ground floor department for gentlemen dark oak was well featured, most notably in the imposing central staircase. The glass-topped counters, simple

hanging garment rails and minimal displays, along with the slightly hushed atmosphere, resembled a Savile Row tailoring establishment more than a clothing store. In common with most of the West End at the time, the store closed at 5.30 p.m. Monday to Friday and at 1.00 p.m. on Saturday.

The management seemed to follow their own very independent buying policy, showing little enthusiasm for the Wholesale Division, except for the numerous special orders that other suppliers would try to avoid. Wholesale seemed to be held in low regard, with complaints of quality and delivery. But nobody seemed to be trying to create a relationship, even though that would have been mutually very beneficial.

The store could eventually become successful if its character could be preserved by an updated but sympathetic refurbishment, but I had no interest in the retail trade as a career. The manufacture of the product had much greater appeal.

8-10 *Bld. Malesherbes, Paris*

The French store had opened before the First World War in 1910 and had an interesting history. I would meet the Director François Jouvent when he attended the board meetings in London. A tall gentleman of about sixty, he was a heavy smoker and strongly resembled General de Gaulle in both manner and appearance. He stayed in a small hotel behind the store (now a multi-storey car park) and I would sometimes have a drink with him after work.

He told me the story with great pride of how in 1940, with the German army advancing on Paris, his predecessor, M. Desborgies, had transferred almost the whole stock of the store to Bordeaux to await the end of hostilities in a region assumed to be unaffected by the war. With the defeat of France in June 1940, the Germans soon occupied the Atlantic coast. The stock then had to be very quickly hidden. An elderly lady, who owned the Rainbow clothing store in Bordeaux and was a Burberrys customer, provided safe storage.

After the war the stock was returned to Paris into a world where any fine merchandise of pre-war quality was non-existent. As a consequence Paris had provided large profits and allowed the French business to act with considerable independence. M. Jouvent did not attempt to hide his low opinion of the recent GUS appointed directors and pursued his own policy undisturbed.

I asked him why he would not use the authentic Wholesale Division raincoats from the Reading factory rather than the mainly French designed rainwear made by an admittedly good quality factory in Brittany. His reply was memorable:

'Monsieur Kitson. You may not like our French raincoats, but they have the merit that they exist.' Spoken like a true French philosopher! I had no reply.

On holiday in Paris later that year I called in to see him and have a coffee in his office. He was very pleasant as usual but not open to any business discussion.

I was shown round the store. It seemed as if time had come to a stop around 1930. The raincoats I wanted to see were piled on shelves and folded shirt-fashion. The staff

were polite, like the long-serving retainers of an ancient château.

There was obviously a place in Paris for a genuine imported British business as evidenced by several local retailers and in particular the nearby French-owned Old England store. A total and very expensive transformation would be required, but should eventually prove worthwhile.

Pandora cotton mill Farnsworth, Lancs

The company had operated its own cotton mill since 1926. Originally on five acres with eight buildings, it manufactured fabric from the raw cotton right through to weaving and weatherproofing. At its head was Ben Hesketh, an elderly main board director. As a result of ageing looms, weaving faults were common, causing quantities of reject garments to accumulate in the warehouse.

New developments with polyester blend fabrics and silicone proofing were put aside in favour of the mill's invention of a cotton and nylon blend (WCN) with claims of total waterproofing. The fabric was promoted by a full running water display in the Haymarket windows. It failed when the nylon began to cut against the cotton during wear – with unfortunate results. Investment in very costly new machinery was highly unlikely. Future outlook – sadly – nil.

90 Wardour Street – Z Division

The woollen merchant business had been moved from Golden Square to this ground floor facility. Before the war, most quality clothing for men was made by tailors offering a bespoke service as distinct from the factory-produced ready-to-wear products sold at popular prices. For makers of expensive quality fabrics, the woollen merchant provided an outlet from which tailors could then order individually cut lengths. This business had been very successful for Burberrys. When ordering from the mills, the name would be woven into the selvedge of the material and 'Made from Burberrys Material' labels were available. The different types of cloth were promoted under a wide variety of stylish names such as: Saddle Tweed, Gamefeather, Cusha, Rusitor, Solax and Urbitor, all available as sew-in labels.

After the war, a ready-to-wear high quality clothing business slowly began to develop, as had happened in the USA. The company Chester Barrie was probably the first in Britain and its founder was an American. The trade began to move away from the more expensive individual tailors, with the result that mills could increasingly sell directly to clothing manufacturers, cutting out the merchant in the middle.

Facing an inevitable decline, it was not long before Z Division would close.

But life returned to the address when it became the Marquee rock music club, which provided the first stage appearance for many famous groups.

New York, 38 E. 38th St.

A subsidiary company since the nineteen-twenties, its function was the employment of a team of salesmen covering the main market areas and selling primarily to specialty stores and a few high class department stores. The orders were collated in New York for manufacture in England. The goods were shipped and billed to the New York office which, after settlement of all freight and import charges, then distributed and invoiced to the individual customers. The largest of these was Abercrombie & Fitch who had an impressive store on Madison Avenue. They were famous for hunting, shooting and fishing gear. Ernest Hemingway was among their many celebrity clients. After they went out of business, the name was sold off to the present retail group.

New York had been very successful for many years but, rather than raincoats, the trade was overwhelmingly in woollen overcoats. The styling was very much the same as the easy-fitting raglan Burberry Walking raincoat, but in fine quality Irish and Scottish tweeds. The trade ran to very large quantities and New York had the additional competitive advantage of being able to draw on the very wide selection of woollens provided by Z Division.

The topcoats were cut and trimmed in Golden Square and then completed by a number of contractors, mainly in the East End of London. With the closure of Golden Square, the contractors had to take on the cutting themselves and as orders were received, they would pick up the appropriate fabrics from Wardour Street. These recent arrangements seemed to be rather unregulated.

Raincoat factory, Reading

Located for many years in Reading town centre, the factory had employed as many as three hundred skilled workers. Prior to the closure of Golden Square where all raincoats were cut as individual orders, the factory had worked more like a large workshop. The cut and trimmed garment would be handed to a seamstress who made the entire garment individually, including the hand-drawn collars to ensure a perfect fit. Buttonholes were similarly hand-worked. Since all orders were treated as single specials, a very wide choice of outer material and lining combinations was offered.

Following the closure of Golden Square, a cutting room was established and a change of production method was begun. Line manufacture was introduced, with operations broken down for each operator to carry out just one process. Orders were grouped together for efficient cutting, which required production planning rather than leaving it to the admittedly experienced but still individual workers. Slowly the change was made from a large workshop to a factory able to recruit and train new workers.

The factory offered to private customers a full service of repairs, cleaning and re-proofing, as regularly used by members of the Royal Family.

29-53 Chatham Place, Hackney E9

The remaining elements of the Wholesale and Export Division were transferred from Golden Square W1, where they had been since 1900. The new location was

the modern four-storey building of the Alfred Polikoff men's suit factory, a recent acquisition by GUS. From the cutting room on the fourth floor down, the building was fully occupied with manufacturing inexpensive suits, but a space was found on a part of the ground floor for Burberrys to use for offices and warehousing.

The primary functions were home and export Customer Sales and Service, including the important liaison with the New York office. This contact was by cable but all other correspondence was in letter form. The warehouse handled the receiving of merchandise from Reading and contractors. It maintained stocks of garments, plus some fabrics and trimmings for outworkers. It dealt with all the packing and shipment of orders for both home and export. The staff from Golden Square were willing and very experienced, although getting on in years.

A not too distant retirement would no doubt be welcomed.

The move from the West End to the East End was probably not much liked, but in 1958 Hackney was a quiet and pleasant inner suburb. There was an evident Jewish population making their slow migration northwards from Whitechapel via Hackney and Stamford Hill until their final destination of Golders Green.

3
GO WEST YOUNG MAN?

B Y THE summer of 1958 there was little for me to
do in the showroom after completing some odd
jobs and providing the interested but sole audi-
ence while Brian Burberry related his experiences running
the family company. I thought he had much of value to
offer but sadly was ignored. The company was now under
yet another chairman, a Mr Price, with still more ideas of
what should be done with the company.

W. S. Peacock had returned to his seat on the GUS
board after completing the purchase of the company. This
left the field open to a regularly changing procession of
Wolfson business acquaintances with solutions to offer.
One of my odd jobs was to reorder the company station-
ery, which should carry the names of the company chair-
man and directors. After two reorders, I decided to ignore
the changes. Nobody seemed to notice.

Peacock senior had prudently appointed his son,
Stanley, to manage the difficult transfer of operations from
Golden Square to Chatham Place. Stanley Peacock was
a young man of about my own age and he asked me to

transfer to Chatham Place. I was ready for a change and we got on well. He wanted me to understudy the export desk.

In those pre-electronic days, communication overseas was by airmail letter. Any long-distance phone call required the intervention of the operator and was slow and very expensive. Contact with New York was by cable wireless. The export of goods required complex customs declarations and negotiating payment terms was by 'Letters of Credit'. I had to translate foreign language mail, but any letters in reply were invariably dictated to a shorthand secretary and sent in English.

One day, I was told to be in very early to meet an important visitor. This was Victor Barnett, a dark-haired young man of very serious demeanour. He was important in the sense that he was Isaac Wolfson's nephew from the American side of the family and he had been appointed to the Burberry board. He announced that he had taken over the New York operation, which at this time was the most substantial component of the Wholesale Division. He was not satisfied with the export department and required me to assume the role of New York liaison.

He explained his intention of making serious changes in the business. He had hired a designer who would shortly be arriving in England to stay for a month and fully brief me on the new plans. In the meantime I should assume control of the Fall order book currently in work with the regular outside contractors. As he took his leave, he said:

'I'm going to be on vacation for two weeks. You can contact me at the Royal Hawaiian Hotel in Honolulu.'

I wondered for a moment if he was kidding. Apparently not.

My function was to process the orders as they arrived from New York, requisition the fabrics to be collected from Wardour Street and issue separate cutting orders for each item to the contractors. Then I would follow the progress of the orders until garments were delivered to Chatham Place for checking before onward shipment by sea cargo. Every consignment used the weekly alternating sailings to New York by the fast Cunard liners Queen Mary and Queen Elizabeth, which took five days. Commercial air freight service was still some way off in the future.

Phil Margolin was the designer. He arrived and booked in to the Mount Royal Hotel for a month. He was provided with an office at Chatham Place and I became his apprentice.

He was very friendly and easy to work with. I was glad at last to meet a professional.

He began by drawing up written trimming specifications for all the woollen fabrics rather than leaving the choice of buttons, sewings and linings to the judgment of the topcoat contractors. We took the train to Reading for my first experience of a garment factory. A new manager, Peter Page, was reorganising the manufacturing process and machines were being substituted for handwork. It seemed a very hive of activity.

Phil set about the design of a new and much slimmer fitting raincoat quite unlike the traditional Burberry. He named it 'Fairview'. The American raincoat business had been very small as the Burberry name was synonymous with the traditional Walking style but in heavy tweed topcoats. These still amounted to many hundreds a season but New York had decided their future was limited. Cars for commuting had replaced public transport in most of

the country and the heavy topcoat was giving way to the raincoat.

The traditional Burberry, they believed, was outdated, with the movement in menswear towards slimmer fitting, Italian-influenced styling. The new model would eventually be adopted as the standard Burberry men's raincoat and go on to become the best selling Piccadilly style. I wondered why there was no designer like Phil working in the English company and giving similar thought to the future at home.

At the same time, there was the completely new development of 'easy care' synthetic fabrics, notably the cotton and polyester Dacron blend so heavily promoted by Dupont – known as Terylene by ICI in Britain. A new silicone finish, promoted as Scotchguard, promised consumers machine washable, permanent weatherproofed (falsely) and stain resistant garments. The old Burberry waxing process was suddenly redundant.

The American raincoat company London Fog incorporated all the new technology with tremendous success. Its advertising showed Big Ben in the background and it was universally believed to be a British product. Phil had been briefed to come up with a genuine British-made Burberry raincoat to compete directly with London Fog.

The clothing business all too often chose copying in preference to risking originality, but I was far too inexperienced to wonder why anyone would wish to buy something they already had unless it had a price advantage. This would be difficult, given that an imported product would have to carry freight and duty charges. Furthermore, Dupont had 'persuaded' the US Congress to impose very heavy import duties (30 per cent) on all synthetic fabrics,

whereas cotton carried an import duty of only 8 per cent on chief value cotton fabrics.

Accordingly, Dacron was out as an option. This meant using an all-cotton fabric and price would be crucial. A lightweight piece-dyed cotton poplin was selected which resembled London Fog but without the Dacron advertised advantages. In order to achieve an optimum making price, it was planned to produce the new coat in very large quantities. Imported in bulk, the stock would be carried in New York and available for immediate repeat delivery to retailers. An energetic Sales Director was engaged from Dunhill who also came over to visit. There was great optimism for the project and I had to admire the American 'can do' attitude, so unlike most of the GUS executives.

Victor Barnett had hinted that the New York operation might well be better set up as a separate independent operation, considering the British side had virtually nothing to offer. I understood I would have a part to play, possibly in New York. I was pleased for myself, since the Americans had the only sensible business plan on offer for Burberrys.

Phil said he would be over again the following year with still more plans for the future.

4

A Rising Young Executive?

I ENJOYED working in the East End, as it was called before gentrifying estate agents changed the name to East London. (Perhaps they had a distaste for the proletarian resonance of 'The East End'.) It was then decidedly white working class and I, having grown up in a northern industrial city, felt quite at home, apart from the cockney accents. I soon began to know the area well as I was living in nearby Islington, also pre-gentrification.

The small Burberry staff in Hackney were far outnumbered by the Polikoff factory workers. They were an extremely friendly crowd and provided me with some new experiences in my very first job. I enjoyed the summer coach day trip to Southend for a fish and chip lunch followed by stops at every large pub on the way back to Hackney. Then there was my first firm's Christmas Party. Work stopped at lunch time on Christmas Eve, and a buffet and bar were set up with music provided from the radio over the factory tannoy loudspeakers. The general flavour may be imagined from a popular game where the men ran the gauntlet of the girls down the trouser floor

and had to reach the end with their trousers still on. My final recollection was being wheeled round the warehouse in a skip before having to be helped onto the bus to try to make my way home. Christmas Day and Boxing Day were holidays but not New Years Day, which was work as usual.

Around the Isle of Dogs were several large pubs with excellent weekend live entertainment on stage providing a popular Saturday night outing with a group of friends. On one occasion some of the Polikoff crowd invited me to a 'Smoking Concert'. This turned out to be a private room in a pub with an audience of about forty men. The Master of Ceremonies was a stand-up comedian telling an endless stream of the bluest of blue jokes in the usual descriptive language. Soon the entertainment began and turned out to be three young women. They were not strippers but rather three young women who simply took off their clothes and then wandered about round the audience to the accompaniment of a colourful commentary by the comedian. The audience meanwhile also smoked a lot.

In the immediate post-war years, the 'Continent' was a very foreign place and no more so than on the question of food. I had grown up with food rationing, even handing in my ration book to the college when I started at university, followed by the culinary offerings of the Army Catering Corps. There was understandable puzzlement therefore when at Christmas 1958 a heavy parcel arrived from Italy as a gift for the office staff at Chatham Place. A hard cylindrical object of about twelve inches diameter carried a Customs declaration: 'cheese'. I, considered as the 'educated' member of staff, was called upon to identify the object.

'I think you'll find this is an Italian Stilton cheese if we open it up.'

Prising open the top proved impossible so I sent for the maintenance man who arrived with his tool kit. After a close examination, he stood back and with a hammer smashed down on the top of the cheese. It flew into many fragments all over the office floor. I examined one.

'I'm afraid this cheese has gone hard on its way from Italy,' was my expert opinion. 'It's not fit to eat so sweep it up and throw it away.'

I had never been to an Italian restaurant. Nor had anybody else. A vital clue that the Italian agent's office was located in Parma passed me by. I had a lot to learn.

I was now allowed the use of my first company car, a not very impressive small black Ford Ten. The condition was that in addition to visiting outworkers around Whitechapel, I had to pick up and bring in to work three elderly tailors from Dalston every morning.

My work was interesting and not very difficult. But all too often workers down on the coalface are totally unaware of disputes at the highest level. A clash of over-elevated egos can lead to decisions with serious implications downstream.

One Friday, I opened the mail to find a memo to staff from the Chairman stating:

'From receipt of this memo, Mr Stanley Peacock will no longer be a member of the company.'

Knowing I was friendly with Stanley, the other staff came to ask me what was happening with the manager. I could see him in his office talking to a visitor and seemingly unconcerned. After the visitor left I went in and holding up the memo asked if he had seen it. He obviously

had not. He got up and I walked with him to the door and his car.

'I'm going over to see my father. He'll soon sort this out. I'll see you on Monday.'

But I did not see him on Monday. Nor for very many Mondays thereafter.

I did, however, see a Mr David Myers. He announced he was now taking over as manager and asked me to show him around. My tour of the single floor premises took very little time and Mr Myers had equally little to say. He seemed as much at a loss as I was. And so began a period of my short business career for which the only fitting description is – bizarre.

My next visitor was my first and only meeting with Isaac Wolfson. He arrived with his usual entourage and asked to see the stock of two or three hundred raincoats rejected for weaving flaws. Once again I was the tour guide as he asked me to point out some examples. He looked and seemed unimpressed.

'I want you to go carefully through these coats again. I'm sure you will find most can be returned to normal stock.' He then departed.

Some garments had already been returned by customers and so I hesitated. Surprisingly, none of the assembled brains, including me, had the wit to suggest that the Haymarket store could probably have cleared all the stock by holding a special sale with one third off regular prices. Maybe nobody wanted to admit to 'slight imperfections'. Certainly my own very first Burberry came out of this stock, selected by the warehouse manager with his recommendation:

'Have this one Brian. It's the top Airylight quality and it's lined with shot silk.'

The coat had been languishing for a very long time, but no customer on my business travels ever noticed any weaving fault. They only wanted to know why we no longer offered silk lined raincoats.

I continued to progress the orders as they arrived from New York, but it was not long before everything changed again. The visit of a certain Mr Strawbridge was announced. He duly arrived in his chauffeur-driven car. Jimmy Strawbridge was very smartly dressed but could easily have been mistaken for a close associate of the East End gangster Kray brothers. He had a similar slightly threatening aura.

As usual, I was the first port of call for all new visitors despite having no title or job description. 'Jimmy S.' was responsible for all GUS warehouse operations and now required my usual quick tour. He wasted few words.

'I understand Mr Myers is out. Is that his office?'

'Mr Myers is away on holiday,' I replied.

'Go and get the van and a warehouseman. Then I want you to load Mr Myers' furniture and take it over to Haymarket.'

Always happy to oblige, we loaded the van with the desk, chair and filing cabinet. Arriving at Haymarket, I reported to the back door that I had Mr Myers' office furniture. The doorman looked uncertain.

'Wait here while I phone upstairs.' A lengthy pause followed. 'Nobody knows anything about it. You can't leave it here.'

Jimmy was not a man to be trifled with. We unloaded the furniture and left it on the pavement outside the store

before driving off rapidly eastwards – mission accomplished. On my return to Chatham Place I was instructed by one of Jimmy's trusties that if Mr Myers returned to Chatham Place, he should be refused entry. It was the last I ever heard of him.

The next stage in my executive career began one afternoon with a massive thunderstorm. It caused a drain to burst and overflow, flooding the lower level of the warehouse with about six inches of dirty water. Fortunately the roof had not leaked so no garments had been damaged, but I had to alert the new warehouse supremo that the part of the warehouse where cloth was stored was flooded.

He arrived within the hour to inspect the scene.

'What's the most expensive cloth you've got here?'

'Mr Price bought that black and white printed cloth when he went to Paris. The cloth is here because we've also got about two dozen coats made up in it and we've had no orders for them.'

All the mainly woollen cloth for the outworkers was stored on steel shelving up to a height of about ten feet and the cloth in question was on the very top shelf.

'Kitson, I want you to climb up on those shelves and throw all that black and white cloth down into the water.'

It all went down with a splash and sank.

'Now get the van and take the coats down to Whitechapel market. Job them off for whatever you can get.'

I asked one of the outworkers in the area to find a market trader and then sold them off for about two pounds each. Naturally no fuss about removing labels.

Life had its amusing side but I had to think that this was not exactly a career.

My wife and I were thinking of leaving our rented flat and buying our first house so I asked to see my new boss and I believe he gave me an honest answer.

'The Wholesale will soon be closing down but I need you to help me with it. If you do, I'll see you get looked after.'

This sounded worryingly like words the Krays might have used. I believe he was quite sincere but his field of business was not for me. While we were talking, he leaned back in his chair and said with a deep sigh:

'If only I'd been born Jewish, I could have gone right to the top in this business.'

All this time, I was the sole connection with New York, but the topcoat orders were down and there was no sign of the large raincoat orders promised. I had read in a trade paper that London Fog were promoting the new 'three season raincoat' by adding a zip-out acrylic pile body warmer for the cold weather, eliminating the need for a separate woollen topcoat. I thought this development could leave New York at a serious disadvantage.

Then I heard from Victor again. He was planning to spin off the New York operation into a separate American Burberry company. He proposed to open a buying office in London free to source a variety of merchandise utilising the Burberry label and import directly to New York. Other than the Haymarket and Paris retail stores, he considered the rest of Burberry redundant. Co-ordinating the retail stores with the American project seemed sensible. He thought I could be interested in running the London office and it sounded a good opening for me. I liked working with Phil Margolin and the Americans seemed to be the only professionals I had so far met.

I heard no detailed plans but it was not hard to guess how the business would work. Haymarket stocked a wide selection of merchandise from a variety of British suppliers. From these, New York would make their selection and place orders. The function of the buying office would be to supervise the progress of the orders up to the delivery date when the suppliers would ship directly to Burberrys New York. This would eliminate the need for warehouse facilities in England but keep the already existing services in New York for importing and onward shipping merchandise to American customers.

It was already known that the Reading raincoat factory would soon have to close by a compulsory purchase order. Once free from the responsibility of the factory, the Burberry raincoats could be produced by contractors both less expensively and only as and when required.

Sensible as it seemed at the time, I am, with the benefit of perfect hindsight, not sorry that this project never came to fruition. I eventually came to the very firm belief that Burberry was a product and not a stick-on label. The core product had to be manufactured by Burberry if the original authenticity of the brand was to be maintained.

I was informed that Mr Strawbridge would now be taking the first steps towards splitting off the American part of the wholesale business and that Burberry at Chatham Place would close. I soon found myself moved out to a GUS warehouse facility in Whitepost Lane, Stratford East. This was in a much rougher area, located next to a malodorous oil refinery. It was the HQ of the Credit Group tallymen where all their little green vans were garaged. The warehouse handled all the merchandise,

loading it into the vans for delivery mainly to good house-wives all around the East End.

We were now reduced to a gallant staff of four with two ex-Golden Square men close to retirement – Bert Miles, a topcoat cutter, and Wally Wools, an orders clerk. Completing the team was Betty Hall, an efficient German secretary who had married a British soldier just after the war.

Jimmy had little idea of what was involved in exporting merchandise but told me that all shipping and warehous-ing facilities would be provided at my request by his staff. It did not take long to realise just what this meant.

5
WHERE'S THE EXIT?

APART of the warehouse was allocated to hang the topcoats from Chatham Place awaiting shipment dates. Most orders were completed and the outworkers were delivering the remainder direct to Whitepost Lane. When the time came to begin packing and start shipping, a young woman from the warehouse was told to follow my instructions.

'Here's what I need you to do, please. As you pack the coats, you have to make out a packing list of every coat in each individually numbered box.'

She stared at me in obvious shock.

'That's no good, mate. I can't bleedin' write.'

It took quite some time to find a literate volunteer to enable packing to proceed.

Betty, our German secretary, then typed out the packing lists and made out the invoices. It seemed we were making progress. Then, although I knew the consignment had to be delivered to Cunard at Southampton, it dawned on me that I had absolutely no idea how to prepare the freight charges for the invoices and the customs declarations.

This job had always been done by the shipping manager at Chatham Place, but a panic phone call soon established that he had been let go as part of the general rundown.

Time was now very short as the freight had been booked for the next sailing.

I held a staff conference with my three associates and we could only come up with one idea. I put all the documents into a large envelope and addressed them for the attention of the captain of the Queen Mary. A curt letter confirmed that Cunard had dealt with the shipment but they requested no further repeat of our procedure. I did, however, learn the simple way to make deliveries thereafter.

By closing the shipment in good time, the invoices could be sent by airmail to arrive in New York ahead of the ship. Cunard then charged Burberrys New York for the freight and customs clearance duties. Learning on the job!

This was not my idea of the future. Chatham Place was due to close and business from New York seemed to be falling far short of their ambitious plans for 1959.

Then I was told Victor had left and the New York operation was to be replaced by a licensing agreement. Burberry would then be manufactured in the USA and the licensee was Louis Roth Clothes of Los Angeles. I met Harry Roth in London and found him charming and cultivated. He said he was a great Anglophile with three Jaguar cars – one for him, one for his wife and one for the workshop! He planned to use the Burberry label for an English-style tailored clothing line but based in sunny southern California; he saw no interest in importing the raincoats from England. It was only much later that

I discovered that, as so often in the USA, English really means English as interpreted by Hollywood. Again, that common language that separates us!

The American market, which had seemed the last hope, was now effectively closed to what had been my function in the business. I started looking for another job but soon found out that only eighteen months in a first job with a troubled company did not make a very impressive C. V.

Meanwhile, Victor's holiday last year must have been a honeymoon for I heard he had married the daughter of Charles Revson of Revlon Cosmetics fame and accepted a seat on the board.

Then I received a phone call...

6

BACK FROM THE BRINK

NINETEEN-SIXTY: STANLEY Peacock called from an office in Polikoff. He had heard that I was looking for another job and asked me to go to see him at Chatham Place. He informed me that in a few weeks a new Board would be appointed at Burberrys. His father William Peacock would return as Chairman. John Cohen from the retail business Scotch House (knitwear) and Hope Bros. (shirts) would assume responsibility for Burberrys Haymarket and Paris. Stanley would head the Wholesale and Manufacturing Division.

I was asked if I would stay until the new board took over and was once again told that I would be 'looked after'. This time I knew I could trust Stanley and his promise was well fulfilled. In any case I was not having great success with job hunting, coming from a company known to be in trouble. And so I eventually found myself back at Chatham Place and found important changes in progress.

Priority had been given to refurbishing the two retail stores to immediately demonstrate a new look for

Burberrys. Alex Froussis, a Paris art graduate and talented store designer, was given the task. He began first at Haymarket by lime bleaching all the old dark oak staircase and fixtures so that a new-look store began to take shape but still keeping a traditional setting.

It was decided that Polikoff would close. Just as Burton's had found, the market for popular price, made-to-measure suits was declining with the move to more casual-style dressing. Chatham Place would effectively replace Golden Square and provide warehousing and office accommodation. Just one floor would be retained for the manufacture of topcoats. The old Burberry staff had now largely departed following the original plan for closing it down, but some well-qualified Polikoff personnel were more than happy to take their place.

Manufacturing was a greater problem. A date had been set for the closure of the Reading raincoat factory. The production was around three hundred a week but falling quickly as workers were already drifting away. It was sad to see skilled machinists leaving to pack biscuits at the nearby Huntley & Palmers factory.

There was, however, a future plan; but this was fraught with great problems. GUS owned John Temple, a large but yet another Burton's-style popular price, made-to-measure suit business with about four hundred shops. Based in Leeds, they operated several factories around the north of England. The plan was to close John Temple in stages and convert their suit manufacturing factories to produce Burberry raincoats. This would eventually involve very large quantities and so require a corresponding increase in sales. It was decided to make a trial start immediately by converting half of the John Temple

Castleford factory near Leeds. Harold Nedas was brought in to oversee the whole programme, but the John Temple production director, a Mr Osman, was very enthusiastic about the project and would prove very capable.

Meanwhile, the closure of the Hope Bros. shirt shops brought to Burberry their small shirt factory at Littleport near Ely. This was a relatively simple conversion. If confined to one style, they could produce about a hundred garments a week.

These ambitious moves urgently needed a plan for substantially increased sales. And so I was made Sales Manager! Such confidence! Such inexperience!

I needed to learn as quickly as possible what remained of the selling organization, since despite all the chaotic changes in the company, some orders continued to come in. I discovered sales were organized on the following lines:

Five representatives covered the Home market: commission agents were in place for Italy, Holland, Germany, Austria and Switzerland. Belgium and Scandinavia were covered by the Export Sales Manager, Michael Dane.

The new licensing agreement with Louis Roth Clothes effectively closed the American market. M. Jouvent, Paris Director, had so far refused to import from Reading, preferring his French manufactured merchandise. There was just one customer in Japan, namely Maruzen, better known it seemed as booksellers.

One curiosity was a Mr Trott. He made an annual tour by sea round countries of the old British Empire accompanied by several large cabin trunks full of samples of Burberry piece goods. He seemed like a ghost from the nineteen-thirties and retired just as I was starting out.

Michael Dane was a jovial ex-army character. We met at Haymarket and he explained how the continental sales agents worked and that I would need to meet them. He made his own selling tours to Belgium and Scandinavia, taking his samples by boat and train on trips of several weeks' duration.

I owe to him my first discovery of that essential foundation of all business life – the expense account lunch. He invited me to join him at the now-long-gone Hunting Lodge restaurant in Lower Regent Street. How could I not be impressed? We discussed how best to take my first steps in the export business. He thought I should make a trip on my own to gain experience, and he proposed Belgium in September. Before that, however, Burberrys were for the first time to take part in the International Menswear Exhibition in Cologne and it gave me my first introduction to the clothing business It was a surprisingly large show and the Burberry stand was kept busy with enquiries from many different countries.

Michael was a kind and also amusing mentor. Reading was experiencing many problems with deliveries and so complaining customers were all too common. Michael had a favourite saying in such circumstances:

'It's the biggest cock-up since Balaclava! '

He spoke his languages quite well but with an uncompromising British accent.

When a small man in a bright blue suit came up and offered his card to ask about placing an order, Michael took the card and examined it closely. Then:

'I'm afraid we could not possibly have on our books a name like that.'

The man looked very puzzled but turned and left. Michael laughed out loud as he handed me the card. 'Can you believe that?'

The card read: *Maison Tits – Bruxelles*.

We returned to London and Michael left for his usual selling trip to Scandinavia. I returned to the Export desk where all business arrived by mail. Going quickly through the post, I opened a letter addressed to -- 'Mr M. Dane, Burberrys'. Assuming it was something I should forward, I was surprised to see it was from a Swedish lady confirming their rendezvous at an hotel in Gothenburg.

I thought for a while and decided it was best just to throw it away. It was the first but by no means the last time I would find that private affairs could very surprisingly surface into the daily routine of business life.

There were signs of improving business as it became clear the Wholesale Division would carry on trading, but keeping Reading supplied with work was a constant problem. Every Friday in late afternoon Stanley, Harold Nedas and I would meet to count up the orders of the week, hoping to keep the factory going. Inevitably there was no time to plan production efficiently, which did not help delivery problems. Fortunately John Cohen was now in a position to instruct the retail buyers of Haymarket, Paris and Scotch House to place as much of their business as possible with the Wholesale Division rather than using their outside suppliers. M. Jouvent, as expected, raised problems and was soon replaced by an Englishman, Peter Howard, who lived in Paris.

Buyers never like being told what to buy and it fell to me to work closely with them. Treating them as our very

best customers enabled me to build up successful working partnerships and their sales figures began to show results. Without the Retail Division change of policy, the Reading factory would certainly have had to go on short time.

Further assistance came to us with the closing down of the woollen merchant business in Wardour Street. Very profitable in the past, it had been overtaken by the new high quality, ready-to-wear clothing makers, most notably in Germany and Italy, plus Chester Barrie in England. It was the end for most of the individual tailors who were now the only customers for the cut length trade. The fine tailors of Savile Row would remain a rare exception.

Robert Sundler was the head of the merchant business and he had been with Burberrys since 1929. He now moved to Chatham Place, bringing with him an unrivalled knowledge of the textile industry just as the mill was having quality problems. It had been merged with some other GUS manufacturing activities and I was not optimistic about its future.

Robert's first task was to source a replacement fabric for the original Burberry fine yarn count and yarn dyed 100 per cent Egyptian cotton gabardine. Although there were numerous piece-dyed cotton polyester blends on the market, nobody was eager to undertake the Burberry specification, presumably as the investment in special looms might not be justified by the demand for a very specialised and expensive fabric. Unsurprisingly, the Japanese were capable and the quality was superb, but the ever-increasing exchange rate for the yen made their fabric unaffordable. Finally, agreement was reached with a mill in Ghent, Belgium, on the basis of guaranteed minimum quantities over a period of time. Although the investment required

a very substantial reduction in the colour range compared with the old original Burberry offering, a very successful relationship evolved.

Planning my extensive programme of visiting all the Continental agents and their customers, I realized I was in need of new clothes. Through my army and university years, finances meant I had bought virtually nothing. I had not been too concerned about my appearance as a temporary Burberry odd job man, but my one and only suit was now seven years old. I was given a staff discount for Haymarket, which was very helpful, but I found the suits still stocked at that time before the new buying policies to be very old-fashioned. Instead, I went over to Aquascutum in Regent Street and bought a nice suit for rather more than I could afford. On my first newly attired appearance I was teased for my 'disloyalty', but I thought it was the best suit I had ever had.

The change of Polikoff to Burberry had gone well and relations were very good. One day I was having lunch in the canteen (the manager's name was Mr De'Ath!) when one of the Polikoff tailors joined me. He showed me some photographs in, I believe, the *Daily Express* newspaper. He said they were taken by his son who was starting a career as a professional photographer.

'Brian, do you think Burberrys could use my boy for some photographic work?'

I thought the photos to be somewhat eccentric given the rather stiff conservative style of fashion photography then current in 1960.

'I'm sorry. I think these photos are a bit too odd for commercial purposes.'

The son's name was – David Bailey.

We began to plan future participation in trade fairs on the continent as a result of the positive reaction from Cologne. There was an annual British UK menswear convention in Harrogate, which we had booked to attend, but we were especially interested in the overseas shows. These were held in locations such as Munich, Berlin, Florence or Paris, but to participate was expensive, given our very limited promotional budget. The Board of Trade organized 'British Weeks' in overseas cities for the promotion of all kinds of British-made products. This seemed the best way to put the Burberry name back in front of international retailers.

However, government funding was not available to individual companies, but only to appropriate trade organizations. We thought the obvious place for us was the British Menswear Guild, a group of better class apparel companies including such names as Aquascutum, Chester Barrie, Daks, Church shoes, Michelson ties and Scottish knitters like Pringle and Ballantyne. By participating as a group, they could qualify for government support and promote themselves as the very best of British apparel.

We applied to join and, to our chagrin, were promptly refused. They appeared to consider Burberrys as falling below their elevated view of themselves. A few years later, when we were clearly enjoying very great success and collecting regular Queen's Awards for Export Achievement, the Guild invited us to join. By then we needed help from nobody and so had the great pleasure of declining the invitation.

Rejected by the Guild, we had to go it alone, but needed some original ideas. With advertising budgets so limited,

it was decided to target one by one some key continental cities. Stanley came up with a formula.

A cocktail party reception should be held in an exclusive location providing a setting for six models brought in from London to present for retailers and press a short fashion show with a light touch of British humour. Importantly, the opening address and commentary would be in the local language.

My French, German and Italian effectively made me the company spokesman, but fulfilling this role suddenly became far more critical. Stanley suffered a recurrence of a debilitating illness he had developed as a teenager. For some weeks he had to rest at home where I would visit to keep him up to date. Even after returning to work he had to be very careful with his health and diet. He asked me to handle all the company's entertainment of customers. He knew my wife was a good hostess and wished her to join the party and avoid dinner from turning into a dull all-male business discussion.

'Be sure to use the best restaurants,' he said.

I soon knew how to do that.

7
ON THE ROAD

P ROMOTIONAL PLANS had to be for the future for lack of an adequate range of merchandise. On offer was the basic Burberry raincoat with two variations: the original unique one-piece sleeve construction or the more recent two-piece sleeve over the shoulder seam model, which was the standard raglan styling of all other manufacturers. There was a selection of yarn-dyed, closely woven cotton gabardines in three different weights – Airylight, Standard or Slimber. Any one of these could be matched as the customer chose with any cotton twill check lining design, and all the fabrics were still being produced by the Burberry mill.

In the old traditional semi-bespoke workshop approach, all orders, irrespective of quantity, were treated as single garments so it was possible to offer almost any variation. This approach would soon cease with the departure of the older skilled workers, to be replaced by an engineered production-line method of manufacture.

A design room had been established at Chatham Place, but before the creation of new designs, their urgent task

was to transfer and adapt the old cutting patterns from Reading for use by the planned new former John Temple facilities. This would involve an element of de-skilling for workers who were accustomed to modern production-line methods. I felt the price of this efficiency would be a certain loss of character in the finished garment, but the old Reading way was inevitably now fading into history.

For me it was time to start a spell of intensive travelling. I became very familiar with the ageing but reliable turboprops of British European Airways on the short haul routes.

My first excursion was to Brussels. I was armed just with Michael's customer list, a price list and fabric swatches. The sole sample raincoat I wore on my back. I was kindly received, making the rounds of the customers. I even took a few orders, possibly from buyers caught off guard by the sudden arrival of an unfamiliar and very inexperienced young Englishman. In Antwerp a customer, George Dick, was even kind enough to invite me to dinner at his home, where he explained how Belgium was divided and that it would be better to address the Flemish speakers in English but the French speakers in French.

In addition to serving export customers visiting the Haymarket showroom, I now set out on my second trip abroad, this time to Amsterdam. I stayed at the delightful art deco American Hotel and went to meet our agent at his showroom in one of the old houses overlooking the Herengracht canal. Joe Luykx was very cheerful and friendly as he took me on the usual round of handshaking customer visits. The new motorway system in Holland even gave me the chance to visit a couple of provincial towns with him.

Back in London it was time to draw together my conclusions about the state of business on the Continent. Firstly, I was struck by the standard of living, which for countries occupied during the war, seemed to be moving well ahead of our own. Secondly, people were well dressed and men all seemed to be wearing a raincoat, quite frequently with a hat. Compared with England, there were more individually owned shops and, with the exception of food, few chain stores. The problems of the Burberry business were remote and the name was held in the highest possible regard among British clothing brands. It was, like Hoover for example, synonymous with 'British raincoat' as defined by the dictionary.

The obvious way of increasing business was to expand the range beyond the classic raincoat. The new cotton synthetics blends with Scotchguard proofing offered one avenue, but there was scope for new garment styles and I had just made several discoveries. First, there was absolutely no interest in trench coats. Maybe the style revived memories of the recent war and any sales in Haymarket were mainly to members of the American armed forces. Secondly, whenever customers were given a choice of raincoat lining, there was an almost universal rejection of the design which was later to become world famous as the Burberry 'House Check'. It was considered 'too loud'. A clear preference was given to patterns toning rather than contrasting with the tan and lovat outer fabric shades. If looked at from the viewpoint of an older conservative gentleman, I felt bound to agree with them.

For the additional styling we required I looked for a short cut. I had studied the Burberry coats in the old catalogues and now discovered that some of them still existed

in the stock of the Haymarket store. The supplier was the Invertere Coat Company of Newton Abbot in Devon. I was interested in the tweed-to-cotton reversible coat as well as several hunting, shooting and fishing models which might fit in with the 'country gentleman' image the Burberry name seemed to project. I had a meeting with the Invertere owner, Walter Sawtell, and agreed he would supply a small range to be added to our own sparse collection. It would be for export only, avoiding any conflict with Haymarket.

The five Home trade representatives gave me the impression of men with little enthusiasm and I wanted to know why. I selected the salesman for the West of England, Frank Wright, and said I would spend a few days travelling with him. I pictured the affluent market towns with their traditional gents outfitters offering good opportunities for the Burberry brand. Moreover, the old catalogues showed many had been customers in the distant past. Frank Wright was a quiet pipe-smoking gentleman of about sixty. He lived in Marlborough in Wiltshire and I asked him to meet me from the train in Taunton.

We began the usual process of calling on customers. The first topic was what had happened to Burberrys, now part of what they saw a down-market mail order company. Unlike the continental customers, they had followed the unhappy story through stories in the trade press. The second topic was price – the old belief that the way to increase business was to decrease prices. The proprietors, mainly elderly, had been too long in the same business and appeared totally devoid of imagination.

We were to stay in a B&B for the night. I was depressed and the taciturn Frank was not sparkling company, at least

until we arrived at our destination. There I discovered how life was lived for travelling salesmen on the road.

The middle-aged but friendly crowd all knew each other and followed the same itinerary. Even the same floating card game would be picked up at where it had been the previous night. I felt out of place and went to bed early.

We carried on next day into Wales and Frank pulled up in a small mining village. I followed him into the general store, which appeared to sell almost everything. We were invited into the sitting room and the unlikely looking owner said how much he liked Burberrys, to the extent that he said he intended to place an order. He went into a lengthy discussion with Frank, which appeared to be followed with close attention by a large parrot from its cage. Eventually a decision was reached and an order was placed for – one coat! I started to say we could not accept such orders, but was so anxious to get away I let it drop.

Wishing to avoid the next B&B, I looked at the map and told Frank I wanted to stay in Port Talbot. Frank said nothing. I thought it sounded like a pleasant seaside town where there would be somewhere decent to stay. My big mistake.

Port Talbot was the site of the largest steel works in Wales. And it was right across the road from the only place we could find to stay now that darkness had fallen. It was above a Wimpy bar, which served as the restaurant. I went straight to bed in a bad frame of mind. I realized that Frank was making it very clear in his own quiet way that he had no wish for eager young men from London telling him what to do.

The night was very cold and the clanking of shunted railway wagons from the steel works across the road went on all night. The room was heated by a small gas fire, which suddenly went out. I finally discovered that it only worked by the insertion of a shilling coin into a slot meter. I did not have a shilling coin. It was 2 a.m., very cold and any staff had long gone home. I took up the carpet from the floor and piled it over the bed in an attempt to get warm. Next morning, I said: 'I'll tell you what Frank. Take me the nearest station where I can get a train back to London.'

I could only feel pessimistic about our chances on the home trade. The feeling was compounded by the very first customer I had to see on my return. It was the raincoat buyer from John Lewis. Rather rudely and without any preamble, he asked to be shown our least expensive coat. I offered to quickly show him a few of the other raincoats he might find of interest even for the future.

'No. That's all I'm interested in.'

'In that case I prefer to leave it until you have a little more time. Good morning.'

I knew that trading on price would never succeed. Someone would always have it for less. I had found a receptive audience on the Continent which would bring more immediate results. The home trade would have to be left aside until we found a good sales manager who really knew the domestic market.

I had now met almost all the export agents. Among them was Erwin Gruener. A small and slightly eccentric man of about seventy from Vienna, he was the agent for Austria, a position he had occupied since about 1936. We became personal friends and he told me stories from his

life. For years prior to 1936 Burberrys had an agent cover-
ing Central Europe, a Mr Vollenweider. He travelled in
great style in his own personal railway coach providing
him with an office and showroom. The coach would be
attached to trains and then parked at the station where he
planned to do business. The greater part of his activity was
the sale of Burberry piece goods in great quantities and his
commission earnings made him extremely wealthy. Then
it was reported that he had committed suicide after losing
a fortune gambling on the stock exchange. Erwin imme-
diately took a plane from Vienna to London, something
of a rarity in those days, and went straight to Burberrys to
offer his services as the replacement agent. His offer was
accepted on the spot.

The Nazi takeover of Austria in 1938 soon obliged
Erwin and his brother George to leave for Switzerland,
but on the outbreak of war Erwin happened to be in
London and promptly interned as an enemy alien. On
being released he spent the rest of the war in England as a
nursing assistant in what was then called a lunatic asylum.
He thought it was very appropriate.

After the war he returned to Vienna to resume work
as the Burberry agent, but only for Austria as the rest of
his pre-war territory was now behind the Iron Curtain.
Brother George decided to stay in Switzerland and
became the Burberry agent for that country.

Erwin served all the best shops in Vienna and the prov-
inces producing good business. I noticed the orders were
almost always just for the classic Burberry raincoat. He
also ordered on his own account, less commission, several
hundred coats a year, always in the same style and one
shade of the heavy gabardine with toning check lining. I

asked him what happened with all these garments. Was he competing with his own customers? He replied:

'It's complicated. Why don't you come to visit me in Vienna and you will see.'

The Mini had recently been introduced. My wife and I did not own a car and thought this would suit us very well. We bought the Minivan version since, as a commercial vehicle, it carried a lower rate of tax. Our chosen colour was light blue.

It was summer and the holiday season. With an almost total lack of forethought I suggested to my wife we should take up Erwin's invitation and drive to Vienna. We had no children, so why not?

It turned out to be less than ideal as a long-distance vehicle, but we duly arrived, found the small hotel Erwin had booked and parked on the street outside. He came over to meet us and found a small crowd had gathered round the Minivan. As we came out of the hotel, he addressed the inquisitive onlookers:

'Can you believe that these two young people have just driven all the way from London in this tiny car?' – at which there did seem to be genuine astonishment.

He invited us to dinner at his apartment, situated close by in the grounds of a private club. The door was opened by a lady wearing a white overall. Not a word was spoken as we passed through the elegant drawing room and followed Erwin into what turned out to be a very large white tiled bathroom. The huge bath was filled with dozens of bottles of cooling white wine. Erwin took one for himself and then handed one to my wife and one to me. He took a drink straight from the bottle and nodded approvingly. He told us the wine was quite young and

from a small vineyard he owned. We took the drinks into a dining room where the table was laid for dinner. The lady in the white overall brought in and served the first course before sitting down to join us. No formal introductions were made, but I gathered the lady, who did not speak English, was Erwin's wife. I could see we were in for an interesting visit to Vienna.

Erwin was evidently a character around the town. Rather short, he always dressed in exactly the same clothes – navy blue blazer, grey flannel trousers and cream silk shirt with a narrow conservative tie. He did not own a car but either walked or took the tram, which is how we travelled around town to greet a few customers. As we walked, he had a habit of stopping abruptly every time he wished to make some particular point, emphasised further by using his hands.

His business was in a very smart street near the famous Demels coffee house. I imagined it located on the street level but it turned out to be on the first floor. There was an office behind which was a large warehouse containing what looked like about a hundred hanging Burberry raincoats. The sole occupant of the office was a small, black-suited figure studying a massive ledger open on his desk. He was introduced to me as 'The Professor'.

The mystery of the large quantities of raincoats imported by Erwin was soon solved. Vienna was on the edge of the Iron Curtain and the Soviet Union together with all the other Eastern European countries maintained large embassies. Within the embassies there was a special shop stocking luxury goods from the West for diplomats and their families, but they also served as conduits to similar shops in all the communist capital cities for the

benefit of the party faithful. Erwin enjoyed the confidence of the officials who controlled this underground trade with the West. It would not do for the toiling masses at home to be aware of the privileges enjoyed by their masters.

On our last day in Vienna Erwin took us out to one of the many *Heurigen* on the outskirts of a city surrounded by vineyards. Naturally, we travelled by tram. These were old inns offering the new wine from their own property. We sat out at long tables in the orchard to enjoy the carafes of white wine. I noticed Erwin had brought a carrier bag, which he now opened to reveal a picnic of Wiener schnitzel and other local delicacies.

We had become close personal friends and when he was in London, he would come out to our house. After our daughter was born in 1965 he sent her a gold locket with an inscription: 'From Uncle Erwin Vienna' – with her birth date.

Driving back through France the Mini began to show signs of fatigue. We were staying in a small town and I went to the local garagiste in his tiny workshop: 'I've never seen anything like this. There won't be an agency in France.'

He said he would look at it and told me to come back next day. I was not optimistic, but: 'Your car is ready Monsieur. I've fitted a part from a Renault, which will work.'

We drove home to London and never had a problem. Happy lo-tech days!

We were now in the nineteen-sixties and my time with Erwin showed the way business had been done in the past. The new establishment of EFTA (European Free Trade Association) in 1960 set up a free trade zone for Britain,

Austria, Switzerland, Norway, Denmark and Sweden. This gave an immediate boost to business with the elimination of customs duties and the associated bureaucracy. What was referred to as 'the common market' was also in its early stages and I assumed that Britain would eventually join.

I was conscious of the undertaking to convert the John Temple factories to Burberry production and rough calculations projected seriously large quantities.

Michael Dane retired, requiring new agents to replace him in Scandinavia and Belgium. Willi Glatt, the agent for Germany, would also soon retire, as inevitably would Erwin and his brother George. Fortunately, the re-emergence of Burberry as a flourishing business soon produced applicants, but they all would have to be trained and introduced.

I started with Sweden, an established market. I selected Stig P. who had a good showroom in Stockholm and seemed well connected. We made the usual rounds and I left after three days, having made customer appointments. He had no car but told me he travelled everywhere by train. I noticed he kept a day bed in his office. He said he lived a long way out of town and at busy times he would be too late for the last train and so stay in the office. It all seemed sensible, but after I returned to London I found the customers had not been visited. My telephone calls all went unanswered and I became both angry and concerned. I sent out a colleague, Roy Hole, with instructions to find Stig. After two or three days, Roy telephoned:

'I've found him. He's in a drying out clinic. I think we can forget him as an agent.'

Despite spending three full days with Stig, I never saw him take a drink. After this experience I sensed my own road ahead might turn out to be 'interesting'.

8
TAKING OFF

I WAS able to find a replacement for Stig sooner than I thought. Step forward Sir Geoffrey Palmer, Baronet. Aged about forty, he had exactly the voice and manner of a Bertie Wooster and the Swedes loved him – 'so typically English'. He had represented Aquascutum in the territory and was among the first of several to join us from that competitor company.

The other openings were quickly filled. We took a tip from Hitler and merged Germany and Austria into one market to be covered by two very experienced men plus a regional sales manager. Vacancies in Belgium and Switzerland were soon filled and I felt that the existing arrangements in Holland and Italy were entirely satisfactory, the latter by the Magnani agency in Milan. I would soon be spending a great deal of time with them, since the very first Burberry show was planned for that city.

Opening up France would be the next major step forward after the retirement of M. Jouvent. Unlike Italy, there was not an obvious welcome for British clothing nor for imported clothing generally. I felt the French believed

they did these things best and had nothing to learn, particularly from *les Anglais*.

We were the first in our industry to sell in local currencies, which required forward currency purchasing contracts. A rapid door-to-door garment hanging service had been started covering the continent by road. We were able to quote a customer in his own currency, including freight charges, and then have his order delivered quickly in factory fresh condition direct to his store. This eliminated unpacking boxes and the need for re-pressing. For the retailer, the argument that this was no different from dealing with his domestic suppliers was the key to getting a start in France, and the three new agents soon began to produce.

I had, however, a problem with the womenswear salesman who had been hired from the French clothing company Louis Feraud. His name was Serge Tchistiakoff and he immediately began to put forward his own, very French, styling ideas. I had to admit our offer for ladies was limited so I called him to London and outlined that I planned to use ideas from old Burberry brochures. His belief in the superiority of all things French irritated me. I told him that if he wanted to sell French fashion he should work for a French company and he was welcome to leave immediately, but he began to see that an original Burberry English look for women might be a gap in the market. I found him very likeable and decided he might benefit from a lesson in English cuisine. It was his first visit to England and he spoke very little English, so I took him to Simpsons in the Strand for a traditional English dinner – but at least with the encouragement of fine French wine.

Smoked salmon to start was highly approved. Roast saddle of mutton from the trolley received a more muted reception including the cabbage, but he was quite prepared to try it. Then the waiter offered the traditional redcurrant jelly, which Serge flatly refused.

'How can you possibly eat meat with jam (*confiture*)?'

I saved my final blow for the dessert – steamed fruit pudding with custard.

He studied it for a moment and then pushed the plate a little to the side.

'I understand now why you name your railway stations after French defeats. I would appreciate coffee and a cognac please.'

We both laughed as we left the restaurant and became the best of friends.

Although not in any way a designer, I was in close touch with customers. I knew there was a special place in the market for ladies' styles with distinct Burberry handwriting. We badly needed to expand sales for women to help fill the new production and engaged a young graduate from the Royal College of Art. She also started to produce sketches for new designs, which were no doubt fine for the general fashion trade but took us into an area already well served by more competent companies.

Time was pressing but I had a few shortcut ideas. Although I preferred the darker toning check linings for men, the bright colours of the subsequently celebrated 'House Check' with its black, white, camel and red seemed much more suited for lining women's raincoats. A proper trench coat for women had never featured in the old catalogues, so I asked the design room to use the men's trench and, retaining all the men's style details, to adapt

the pattern just enough to fit a woman. Suddenly there emerged the classic Burberry ladies trench coat with a 'new' old lining. It was an immediate success and soon far outsold the men's trench to become the foundation stone of a new women's collection. The way ahead was clear as the same approach was applied to the original ladies' Walking style raincoat, also in a reversible tweed-to-cotton version. And that was it for now, but this simple step opened the door for a huge increase in sales for women. It was to be helped by events that would occur in another part of the company.

During the same period, the refitting of the Paris store was almost complete. The management were equally concerned at what they felt was the inadequate offer for ladies from Burberrys Wholesale UK. We were working on completely separate lines and their favoured solution was to hire a merchandise manager from Dior. She was commissioned to produce a ladies' outerwear collection to be manufactured in France with a much more contemporary fashion image. I had just been down this same road with Serge Tchistiakoff but with rather different conclusions. The new line for the Paris store would be presented to the press during a show in the newly refurbished ladies' department. Two weeks before, a carefully selected party of about a dozen of the most influential journalists was to be invited to London for a special preview, followed by a dinner party at Annabel's, then newly opened.

I was introduced to Jacqueline Dilleman at Haymarket and we agreed that I should oversee the sending out of the three English models into the showroom according to the programme, while Jacqueline made her presentation to the journalists. The highly fashionable garments

were of a superb quality but, I felt, a completely different concept with not much in common with Burberrys except the label.

From my vantage point I could see the reception was rather restrained. On no more than a sudden whim at the end of the official programme, I sent the girls out with three of our rather basic styles, the last being the new trench coat. The girls on their own unrehearsed initiative made a big show of the check lining and to my very great surprise they were received with enthusiastic applause. Jacqueline was shrewd enough to make it seem as if it had all been planned and wound up the show. An immediate result was that the editor of *Elle* magazine, Helene Lazareff, featured the trench coat on the cover of her next edition, stating that this is the coat to wear 'to be chic in Paris today'.

Jacqueline made some rapid changes for her Paris show two weeks later. She asked me to rush fifty metres of the check lining to Paris. She had grasped the opportunity very quickly and had made up an umbrella and a shoulder bag featuring the check. She put small round tables among the chairs for the show and covered them with the check. Roy Lack, director of the Haymarket store, had just had made a sample cashmere scarf in the check. It too was added to the cocktail mix, and we suddenly had an accessories collection. It was the work of several hands with an injection of pure chance.

The show was received with very great acclaim and everyone was happy. Jacqueline and I never discussed my unscripted intervention in her London presentation, but we did become very good friends. After the show she gave

me the original umbrella and bag as a souvenir gift for my wife.

The difficulty had been to find a direction but from then on it all became rather easy. In my mind, the focus on an old check design had begun as a publicity stunt to sell raincoats for women. It now became referred to as 'The House Check' and used wherever possible throughout the whole collection. I was afraid it might run the risk of falling into dubious taste and it was not long before cheap copies began to appear. There was a sudden panic rush to register the design, but we were unable to prove original ownership. I had a 1935 Burberry fabric collection and it did not contain the design. It did, however, have the same pattern, but in navy blue and red. Making sure we added it to the collection, an application to register was drawn up and sent to the relevant authorities, naming me as the original designer. It was at least a nice try and better than nothing. I thought it might be prudent to confuse the issue and repeat the same design, but used the huge range of Shetland wool yarns from Hunters of Brora to produce some beautiful colour mixtures.

The Paris event was a turning point for the company and every season from then on, we held cocktail party shows in all the main European cities – Lyon, Vienna, Amsterdam, Stockholm, Rome, Brussels, Hanover and Berlin.

We included Edinburgh almost too successfully: the party ended with most of the guests being helped out semi-conscious. The company was too rough for me.

The first continental show was in Milan and set the formula for all the others. The guest of honour on this occasion was Douglas Jay, President of the Board of Trade

under Harold Wilson. He gave a short address, although I thought his rather rumpled suit not the best advertisement for British tailoring. I was to act as show commentator, in Italian. The Milan office staff had provided me with coaching to such an extent that I appeared to have a total and fluent command of the language. When I had to answer questions at the end of the show from very fast talking Italians, my deficiencies were swiftly exposed. Italy soon went on to become our best continental market and my command of the language began to improve accordingly.

The other shows followed a similar format as originally conceived and using six three men and three girl models kept the time down to about twenty minutes. Since we did not offer a wide range of different styles, the 'Burberry Look' was produced out of a mildly amusing mixture of themed music and accessories.

The conversion and retraining of the John Temple factories was proceeding at a steady rate. Reading was now closed, but Castleford was completely turned over to Burberrys. The next factory planned was at Blyth in Northumberland. It was equivalent in size to Castleford. Meanwhile, the small John Temple trouser unit in Whitby converted to manufacturing the new ladies' trench coat. Having only the one style, it was soon producing just over a hundred a week, happily covered easily by the excellent sales.

I was surprised and relieved to find that the John Temple workforce soon proved they were well able to meet Burberry quality standards. The capital investments were high but offset to some degree by saving the cost

of redundancy payments to hundreds of workers, not to mention the very bad publicity GUS would have faced with the closing down of John Temple.

However, by my rough calculations these factory changes, added to Littleport, would eventually lead to a total production of two thousand raincoats a week. This was a sobering thought and so I made time for regular factory visits. I was very supportive of British manufacturing, all too often let down by some poor management. Each factory held its own company dinner and dance at Christmas and I tried to attend them all, but in the process, I became known as 'the boss'.

I then began to receive anonymous letters, always from women. After I realized a factory was staffed ninety per cent female and only ten per cent male, the latter usually in more senior positions, I threw them all in the waste bin. But one day I was caught off guard. Reception said a 'Mrs D.' was asking to see me. I knew the name as one of the original Golden Square warehousemen and a nicely dressed, middle-aged lady, complete with hat, came in. She asked if I could not send her husband away on business so often. Thinking quickly, I said I would look into it. She left and I called the errant husband in. Without mentioning my visitor, I told him that if he ever again used my name for his private purposes, I would fire him. Their problems were between themselves. I was learning on the job again.

The business was on a continuing upward curve. I was allowed great freedom to make decisions, but also knew this was only due to the regular and substantial annual increases in sales. The expansion of the retail division was

a great help. I worked closely and personally with them, considering them our largest customer.

Another of the GUS tailoring businesses, Hector Powe, was closed. They had a large store on Regent Street, which was converted over to Burberrys. Since the once high-class Haymarket had now become increasingly surrounded by tourist souvenir shops and fast food chains, a Regent Street location was very welcome. In Paris, the gradual closure of a GUS-owned chain of shirt shops offered new opportunities to expand, beginning with a store on rue de Rennes. The increase in retail division orders greatly helped the new manufacturing operations.

Other developments saw the establishment of Burberrys Spain, a licensing agreement with the Spanish licensee of Fred Perry. It was during the time of the dictatorship of General Franco and the poor state of the Spanish economy made imported merchandise unaffordable. In this case, licensing was the only possibility of doing business.

I went down to Barcelona on several occasions for the setting up of a factory to produce Burberry raincoats. It very soon became clear that outside the cooler Atlantic north, the climate would not support year-round manufacturing of raincoats. Gene Mora was the elder son of the original business owner and had studied in the USA. He soon decided to move the production into the new area of casual but quality sportswear and he did so very successfully.

Another licensing agreement was with Mitsui of Japan. Apart from Burberry's old customer Maruzen, I had no knowledge of the country and was sceptical about its

future prospects. Moreover, the delegates from Mitsui were very small and very elderly, and very boring. I excused myself from the negotiations. Although they finally agreed to import some raincoats from England just for Maruzen, the contract effectively excluded us from Japan. I realised some years later, with the rapid growth of the Japanese economy and the strengthening yen, that we might have made a big mistake.

The success of the company brought an outstanding three Queen's Awards for Export Achievement. We made sure the presentations were made in front of the workers in the factories so they could feel a personal involvement.

I had travelled a great deal throughout Europe and had often taken my wife to help with customer social relations. I loved Europe for its culture and diversity, so unlike the present move towards a monostate 'Eurobland'. Working with the differing national characteristics, I found that, given a very fluent and idiomatic command of their language, the French were the most entertaining and wittiest company. I only had one unpleasant business dispute with a French customer. It was a store in Strasbourg that I considered unsuitable for Burberrys but whose owner insisted on placing an order. There seems to be a law for everything in France, frequently disregarded, but in this case I was quoted the law of *refus de vente*, meaning I was legally obliged to accept their order. I sent word through a third party to say we would accept the order as the law provided, but owing to technical problems in the factory, we could not guarantee every coat would have a full set of buttons. We heard no more.

France had become our second-best market after Italy and easily the best for womenswear. French women seemed to know how to wear *le style anglais*.

Since we no longer exhibited at the SEHM menswear show in February and September, we held an 'open house' in the Paris showroom over the weekend during the exhibition. My wife would come over for the weekend to help out as we entertained customers in the evenings. Fouquet's was a favourite restaurant and sometimes we made up a party at one of the newly trendy disco clubs. As a result my wife became all too well-known to some of the Paris showroom staff.

Patrick Gouzik was the owner of the Rainbow store in Bordeaux where a previous owner had hidden the stock of Burberrys Paris during the German occupation from 1940 to 1944. After placing his order in the Haymarket showroom, Patrick asked if he could see me in private. It was the beginning of a story worthy of a novel by Simenon.

Once in my office, Gouzik began: 'I wonder if you can now settle the bill for your wife's mink coat.'

What????

I was totally confounded and told him my wife had a mink coat but it had been bought from Harrods. The story then began to unwind. The Gouzik family were originally from Poland where they had been in the fur trade. Patrick's father was a master furrier and continued to work in Bordeaux. A telephone call came from Burberrys in Paris with a request, as a favour, to make a mink coat for the wife of an English company director. The father arrived at the Paris office where he was introduced to an 'English lady' as Mrs Kitson. He took measurements to finalise the lady's order, after which he took the train back

to Bordeaux. The coat was made and delivered to the Paris office, but later could not be traced.

I could only offer to carry out an immediate investigation but needed local help. Jacky Aloro was the menswear agent for the southern sector of France and a close personal friend of the Gouziks. Jacky lived near Nice after moving from Algeria after the war. Small, full of nervous energy and a constant Gitanes smoker, he was like many in the clothing trade who had left Algeria and who were known as *pieds noirs*. Some time had elapsed, but he found the date of the phone call by a man from Paris to Bordeaux plus a description of the 'English lady' from M. Gouzik.

Suspicion soon fell on an individual whose girlfriend had also worked in the showroom at the time. She had left not long after the coat was delivered. The boyfriend found another job and soon also left. The feeling in the office was that the man was infatuated with the woman. In order to impress her, he might have been persuaded by her into a reckless act. It sounded a very French story and surely Inspector Maigret would have trapped the culprits. We were less able to prove our suspicions in a case of *cherchez la femme*.

The Gouziks had to accept their loss and I was angry and frustrated that my name and Burberrys had been used to cover a criminal theft. The whole story eventually entered company folklore as the *histoire du vison sauvage* or 'The case of the wild mink'.

At first the Germans were slow to react to the Burberry revival, with interest confined to a few older traditionalists whose names often contained a 'von' somewhere. The French and Italians took up the product purely on

its merits, but Germany waited until Burberry became known as an indicator of social status, especially with the advent of the high-profile House Check. Business then took off strongly and if the German customer might be described as *nouveau riche*, the whole Bundesrepublik with its capital in Bonn could in the sixties also be described as truly *nouveau* after being totally rebuilt on the ruins of 1945.

Their great economic success made some Germans arrogant, but I, a child of World War Two, was more than happy to respond in kind. They demanded their coats sized by the metric system and four centimetres longer than our standard. I refused. When customers design the product, the value of the brand becomes reduced to a mere factory operation.

Another subject for frequent dispute was the exchange rate. We were now selling in D. marks (Deutschmarks) at a time when the DM rate against the pound was moving steadily upwards. A customer in Mannheim, whom I knew quite well, decided to utilise the contact to ask me for a discount in view of the movement in the exchange rate. I felt obliged to tell him it would not be possible but a new rate would be applied next season. He became unpleasantly insistent, threatening to cancel his order, which he had been happy to place in convenient D. marks, if I would not agree. I told him to consider his order cancelled and hung up. I knew that if I agreed, it would start a general bidding war and all contracts would become meaningless.

Our product was selling extremely well in Germany and, quite unashamed, he turned up at the Düsseldorf showroom the next season. The staff knew of our dispute and telephoned asking what to do. I instructed them to

inform him that we were completely sold out and he could try again next season if he so wished.

He so wished and the subject did not arise again.

I did not enjoy these confrontations, which happily were rare, but I could not let the company give in to threats. By total contrast, I formed a close personal friendship with Hans Alfred Terner in Hanover, a Burberry traditionalist, who became the largest German customer. My wife and I visited every year and enjoyed some very serious hospitality. It transpired that we had a faint family connection. Hans Alfred had spent the war in Germany but in hiding. His younger brother John and his sister had escaped in time to England. John, technically still a German subject, joined the army as a volunteer and ended up in the same 11th Armoured Division as my uncle and with the same function of battlefield tank repair and recovery. These were the same tanks which later liberated the pitiful inmates of Belsen. John found his brother still undercover near Hanover and they set out to find their parents. The mother was still alive but their father had been gassed. The sister went back to Germany and eventually worked for Hans Alfred, but John decided to live in England after the war and started his own ladieswear business. I arranged for John and my uncle to meet over dinner in London and enjoyed listening to the stories of their adventures.

The Italians were the most enthusiastic customers of all. I learnt more in Milan from them with their instinctive fine taste and colour sense than anywhere else. I felt this was best to be seen in Italian menswear, which I thought of as rather 'chic conservative'. Aquascutum had a strong presence in the market at first but were eventually overtaken

when, for men, the classic Burberry raincoat almost became a uniform on the streets of Milan.

Throughout the time of my travels I could always rely on the organization at Chatham Place. Colin Wilson acted as my deputy and was rather better suited than I at ensuring the organization necessary for a smooth running office. He had by now overseen the installation of the first computer programming – not my forte. Orders still arrived by mail at this time but were now rapidly analysed both by market and fabric content, with a consequent great improvement in production planning efficiency. I disliked 'executive style' round-table meetings with coffee and biscuits to accompany the ritual of minutes and agendas, while people sat around feeling obliged to think up something to say. A cruel old saying I had once heard would come into my mind:

'When I want your opinion, I'll give it to you.'

Meetings with no more than one or two people, often involving Colin, usually led to faster and better outcomes.

9

On Tour - Further Afield

A S THE nineteen-sixties drew to a close, business on the continent had become well developed with an excellent customer network and healthy demand. Sadly, the once thriving cities of Eastern Europe were no longer visited by a Burberry agent in his private train, but lay behind the Iron Curtain.

With the exception of London, the domestic market did not show comparable strength. The merging of independent department stores brought group central buying and a search for cheaper goods. Stores in locations featured in the advertising of the British Tourist Authority reported that visitors accounted for most of our sales, a trend repeated in Burberry's own British retail stores. Since Europe was now becoming a single market, I accepted this geographical variation, hoping for better days.

With a largely satisfactory selection of stockists, I saw no more need for trade exhibitions such as SEHM in Paris. Instead, the sales conferences held twice a year in London brought together all the agents for the new season briefing and also for some serious partying. All were independent

businessmen, but together they displayed all the confidence and high morale of a successful sports team. And so they should, since they were earning a great deal of money. All payment was strictly by commission only, and I took the view that their higher earnings meant more business for the company. In fact, it was their customers who really paid them. Also, life on the road did not always favour marital bliss and I believe alimony payments kept several of the agents highly motivated.

The high company profile began to attract approaches by a number of well-known designers, from Pierre Cardin to Mary Quant. Their proposal was that we should produce and sell raincoats to their designs and then pay them a royalty. Good for them but useless for us. Some other requests were for our merchandise but without our label. Brooks Bros. could have been a suitable customer, but they did not stock brands and we would not supply on a private label-only basis.

A similar question with Harrods ended in a sensible compromise. We made up a Burberry label, adding the simple text – 'Made exclusively for Harrods'.

We had not spent greatly on direct press advertising. To achieve visibility, we had selected key cities for a cocktail reception and style show. We looked for well connected sales agents to place the product into all their finest retailers, which worked like a product endorsement. Then, it was the almost accidental rise to prominence of the House Check, like a spotlight on the brand, which brought so very many column inches of free editorial publicity. Inevitably, maximum use was made of the Check as a publicity generator, disproving my concern about the risk of overexposure.

I was constantly aware of the factories and their permanent need to be fed. I had seen the demise of the Lancashire cotton industry and was currently an unhappy spectator of the slow death of British-owned car companies. Even the soundly based Yorkshire worsted suiting industry was surviving by a series of mergers. In the final account, failed manufacturing almost always results less from unions but from poor management, added to the distrust by bankers of necessarily longer-term investments. My ambition was to avoid these pitfalls.

The American licensing agreement had brought no benefit to either party and I knew some renegotiation could not be indefinitely delayed. Re-opening that huge market for the British product would secure our manufacturing base. But once again, two new opportunities arose closer to home.

While on a visit to the Rome office of our agent, I was quietly called aside by Luigi Magnani. He told me in a very confidential tone that he wished me to accompany him to the Vatican. The 'What'!!?? Mussolini had made the Vatican into a separate state within the state of Italy. As such, it was able to make its own diplomatic and taxation arrangements. Luigi explained he was in negotiation with a tax-free store used by the inhabitants and staff of the Vatican. In an even more confidential tone, Luigi went on to explain that he had taken our official price list, which included his commission, and reproduced it with increased prices so that an unofficial extra commission could be paid to the Vatican store director. It seemed Luigi's idea was that the presence of a Burberry director from England would lend some spurious legitimacy to a dubious transaction.

We held a polite meeting with the director, who had already seen the collection in the Rome office. After a further exchange of niceties we were handed the order in an envelope and left. Too curious to wait, I opened it in the street. I found a very good order for several hundred coats, many in expensive fabrics such as cashmere and lambswool. I looked again.

'Luigi, wait a minute. Do you realize eighty per cent of these garments are for women? Since when do nuns run around in cashmere coats?'

An even more confidential tone was adopted for the answer:

'You see, those who are in the Vatican can have a special card entitling them to make tax-free purchases. There is a way for the cards to be hired out for a day to allow regular Roman citizens to use the tax-free shop. It is generally known.'

I wished Luigi good luck and said I had no objection, thinking *how very typically Italian*. But what really made me laugh most of all was that the Vatican director of the tax free shop was – Jewish!

I asked Luigi if he thought we could add His Holiness the Pope to our list of Italian stockists. He looked down. After a pause, he said: 'Probably not.'

A call came from our Paris office informing us that an agent from Beirut was asking about the possibility of introducing Burberrys in the Lebanon. I had never given any thought to 'East of Suez' while Burberry raincoats remained the main product. I had been on holiday to Morocco and assumed Lebanon would be more or less the same, with endless haggling over every commercial

exchange. I thought it only polite to follow up the contact from Paris, but found a situation not at all as I had thought.

After the First World War, the Ottoman Empire was divided mainly between Britain and France. France was given a mandate over Syria and the Lebanon, while Britain had Palestine but more importantly established Iraq to exploit its oil through the British Petroleum Company. The French encouraged the use of their language as well as introducing their own attractive French way of life.

The end of the Second World War brought independence and an end to French control, but left Lebanon a very attractive country. After the agent had brushed up my history, he went on to explain that Beirut had become the playground for the enormously wealthy Arabs from the Gulf wishing to exchange the fierce heat of their summer for a pleasant Mediterranean climate. There was everything catering for their taste for obvious luxury plus certain pleasures not permitted by the strict religious observances at home down on the Gulf States.

It sounded like a great opportunity to me!

Full of optimism, Roy Hole and I put together a sample collection making full use of the House Check accessories. The agent advised us that the Arabs travelled all over the world but liked to do their shopping in the congenial atmosphere of Beirut. We flew out by the main carrier at that time, the soon to be lamented Middle East Airlines, and after a customs examination, we were on our way to the St. Georges hotel, superbly situated on the sea front. The view up the coast from the balcony of my room reminded me of Nice and a subsequent stroll up the main

shopping street showed an impressive selection of very high-class stores.

We soon found excellent restaurants with fine Lebanese wine and also noted the night club scene was very active. Wine, women and song, but with extra women.

Our agent was from the French-speaking Christian community who seemed to occupy the upper reaches of society. The rather post-colonial atmosphere clearly placed the Muslims in the lower reaches, and it could be seen that not all of them were very happy about it. The agent introduced us to what we agreed were three high-class stores. It turned out that all were owned by members of the Armenian community, said to be known for their business acumen, and we soon wrote orders with all three. French merchandise was everywhere but virtually no British presence. We thought we had the foundation of a thriving future market.

The sight of so much opulence in the shops of Beirut decided us to examine Arab wealth at the source. We flew down to Kuwait and as the plane came in to land after dark, the hundreds of burning gas flames on the oil wells made for a scene from Dante's *Inferno*. It was very hot as we disembarked but next morning the heat beat down like a hammer as we ventured out for a quick look around the town. All the men were in traditional Arab dress and no women were to be seen. We soon realized we had wasted our time after we found that in Kuwait retailing had not progressed much beyond the oriental bazaar. We could find no clothing stores and the only brand on display was the inevitable Pierre Cardin.

It was more than obvious why all the action was in Beirut – and, with absolutely no chance for a long-chilled

G. & T., we followed the Arab example and caught the next available flight back to Beirut and civilisation.

The next morning on our way walking back to the St. Georges I had a sudden fainting fit and fell down flat in the street. Roy got me into a taxi and the hotel doctor diagnosed sunstroke. He ordered me to rest in bed for twenty-four hours. Feeling better, I finally had time to catch up with the news in the local English language newspapers and was struck immediately by a headline jumping off the page:

'Enemy planes active over southern Lebanon.' What enemy? I soon guessed.

I knew nothing of the intermittent clashes on the southern border between Muslim guerrillas and the Israeli army, other than a warning not to try to enter Lebanon with an Israeli entry stamp in my passport. I had thought nothing of it until I read further in the paper of a case concerning an 'Arab Boycott List'. From this I gathered that dealing with any company listed as a benefactor to Israel constituted an offence to be tried not in civil court but by military tribunal.

The term 'Arab' only raised for me a vision of Peter O'Toole riding around as Lawrence of Arabia and seemed not to apply to a very westernised country like Lebanon. I had no doubt GUS was a major benefactor to Israel and would surely feature on the List, but I had assumed this would not include Burberry.

I thought it advisable to call the agent. He was quite incredulous at the idea of a Burberry listing, but agreed to send a man round to the Boycott List office to check. He soon called back greatly concerned to confirm that we had made the List. He had further found out that it was

an offence both to offer as well as receive goods from a banned company. He hung up abruptly and our friendly relationship ended on the spot. When Roy came in I explained our situation and showed him the article in the newspaper.

'Roy, I think we know who might have paid for those planes.'

He reacted quickly: 'Let's head for the airport!'

I decided instead that we ought to be very British and not make a quick run for it. We called on the three would-be customers and were very kindly received. After all, we had saved them some serious trouble. The man who had placed the largest order said it was a pity, as he felt certain he would have done well with the introduction of Burberrys into a new market. He then graciously invited us to a very nice lunch and we all thought we had lost a great business opportunity. But we were wrong.

On the way back to the airport for the London flight I felt some new concern as we passed refugee camps full of displaced Palestinians covered by armed guards. Despite these signs, I did not foresee how the growth of the Muslim population in the Lebanon would so soon lead to the outbreak of a brutal civil war, which would destroy cosmopolitan Beirut and last for years. This beautiful country today still remains a dubious destination.

As a result of the war, all the massive spending power of the Gulf Arabs we had hoped to exploit in Beirut abruptly left and was quickly transferred to London. We lived at the time near Harrods. We observed the outcome daily at very close quarters and took to unkindly renaming Harrods as 'Arrabs'. Burberry benefited from the lavish spending along with other London retailers and its

products was also now available in most airport duty-free shops. In Britain it seemed as if the name and the House Check had suddenly become a part of the national tourist industry.

As soon as the plane from Beirut left the ground we ordered with some relief two very large drinks. My taste for travel to exotic parts was well satisfied, but we still needed to find a source for a very big expansion – and there was only one. I was determined there would be no more delay in starting a serious discussion about our future in the USA.

I would soon be on yet another plane and glad to be heading west rather than east.

10
HEADING WEST

NOT LONG after my return from Beirut it was agreed that I should make an exploratory visit to New York.

Looking at the world in 1970 for possible markets beyond Western Europe, I had visited East Berlin, Budapest and Bucharest. There was no opening for expensive consumer goods such as Burberrys. The Iron Curtain seemed here to stay unless a nuclear war ended it, along with everything else. Vietnam dragged on and China might be headed back to the Stone Age after Chairman Mao.

The world of today was beyond any imagination at the time so I was convinced the centre of gravity of the business must be pushed west towards the USA – the only remaining worthwhile and unexploited market.

I felt I knew and liked Harry Roth well enough to raise the subject and I had every confidence in the new merchandise we were producing. For the sake of a licensing contract originally agreed too quickly as a short-term solution, we had given up everything and gained nothing.

But our licensee was in the same position, so the opening gambit was obvious.

I called Harry to see if there was anything I could do to help him with the dormant import business. He was more than happy and offered an office for my use. Roy Hole was in Canada on a sales trip. The vast distances and relatively few customers made the market unattractive for an agent. We agreed to meet in New York. I had a private and personal motive for the trip since as a lifelong jazz fan and regular visitor to the Ronnie Scott club, I considered New York the world headquarters of jazz.

I booked my very first ever transatlantic flight and it turned out to be memorable. Over New York, the captain announced that there had been a failure in the air traffic control and due to bad weather conditions plus running low on fuel, he was diverting to Boston. I would willingly have left the aircraft there, but my request was refused and we took off shakily in the teeth of a very strong gale to try New York again.

Roy had booked us into the rather splendid St. Regis hotel where I finally arrived some time after midnight. Roy, relieved, then accompanied me for my first meal in the USA. It was in an 'all-nite' deli on Sixth Avenue and I though that it was wonderful. Everything seemed strangely familiar to me as if I had been there before, until I realised that the films of Hollywood were the likely reason.

Next morning after a restorative breakfast, I was waiting for the elevator to return to my room, when out stepped Salvador Dali with a tiny dog on a lead. What a country! Roy and I walked down Fifth Avenue to the Louis Roth store where the office was on the top floor. The manager,

as he greeted us, proudly displayed a six-shooter revolver tucked into his trousers. What a country! And so much more fun than Europe even in the first twenty-four hours.

Up in the office were two desks and two telephones. I had resurrected the old customer list from ten years ago. Taking half each, we started on the telephones. The responses were not encouraging, some even hostile. I was handed possibly the worst put-down of my career:

'Mr Kitson, even if I needed Burberrys, which I don't, I still wouldn't give you an order.' Click.

A week was never going to be enough to gain anything more than a slight understanding of the market. It was evident that Aquascutum had taken up Burberrys' place in all the better class retailers and the American London Fog raincoat occupied the rest. Trench coats were clearly far more popular than in Europe, but then I found American retailers very reluctant to buy as soon as customs import duties and foreign currency were mentioned.

I had to admit to Harry that I now had a better understanding of his difficulty with imported merchandise. I offered to send a young salesman from England to live in New York and work full-time on the problem if Harry would provide office services. Tony Kellond was about thirty, from Leeds and married to a German girl. His parents lived in Spain and he was quite happy to move overseas. Harry liked the idea and his political connections soon secured the vital 'Green Card'.

I told Tony to call on potential customers on the East coast and at least give out brochures to remind them Burberrys still existed. He obtained a few orders, but most importantly for the future, Barneys in New York became our first serious customer. They specialized in importing

from Europe merchandise not widely found on the market to draw business to their offbeat location on 17th Street.

Meanwhile, I had begun working on a few ideas, which would require a personal meeting with Harry in Los Angeles. I had so far seen nothing of America outside New York, so I decided to make for Los Angeles via San Francisco. I had been told that this was the most 'European' city in America, which sounded promising. The view from the plane as we landed was my first sight of the Pacific and Tony and I checked in at an hotel near Union Square.

The feel of the city was quite different from New York. The Golden Gate Bridge and the clanging cable cars were very familiar from years of Hollywood movies.

Tony had set up some appointments on the West coast starting in San Francisco. The first was with Roos Atkins, a large clothing store in the downtown district. I called the buyer to confirm the time, but he told us not to come. When I said we had come all the way from New York with samples for an appointment, he curtly replied:

'I've changed my mind.' Click.

It was not the best start, so I was delighted to learn two years later that Roos Atkins had gone out of business, so we probably would never have been paid.

We made our other calls and the reception was generally friendly, but it soon became clear that the Louis Roth association was not right for the conservative stores we were aiming at. Unfortunately, it was the only organisation we could offer to serve the market and I would soon discover why we had made a wrong connection. Selling trips from England were a possibility but made

no economic sense without a commercially compatible American partner.

We went out to one of the many small cafés for breakfast. When I ordered fried eggs, I was asked if I wanted 'sunny side up or over easy' – a new experience, as was the offer of 'pink eggs', which translated as pancakes. The coffee was plentiful, but very weak. A glaring opening awaited the arrival of Starbucks.

Life moved at a slower pace than in New York and the city centre was comfortably walkable, notwithstanding the steep hills, when the cable cars came in handy. The sights on the streets were instructive. There was a conservative formal style good for Burberry, but it was combined with a free-wheeling hippy vibe. Near Union Square I was amused at the sight of a souvenir shop displaying a T shirt printed 'Nuke The Whales'. I was tempted to buy it in sheer admiration for just three words able to offend such a very wide spectrum of opinion.

We sampled the food in touristy 'Chinatown' where the restaurants were all much the same; we decided the Chinese restaurants in London were more varied and rather better. Later in the evening after our Chinese dinner, we came upon a lively street offering entertainment of every description. We were soon drawn to the numerous garishly flashing neon lit bar signs: *Girls! Girls! Topless! Topless!* Something I had never heard of and something to try.

The place was crowded, noisy and all male. Accompanied by loud rock music, several attractive but topless young women were walking along the top of the bar so that their knees came just to the audience's eye level. But what really struck me was all the noisily chattering

men paying not the slightest attention to the show just inches away, so much so that I felt it almost gauche to look.

We soon moved on down the street to find a quieter bar for a drink and some cool West Coast jazz.

The climate made San Francisco potentially an excellent market for Burberrys so we decided to drive south down the Pacific Coast Highway and eventually to Los Angeles. We visited affluent Carmel: if it had been Europe, this would have been an ideal town for Burberry business. Although everything was a new experience, I had begun to recognise what would be compatible with Burberrys. A sociological element existed in what was said to be a classless society.

I always enjoyed American writers and had read a great deal of their fiction. *The Great Gatsby* was a novel I found especially instructive when it now came to decoding American menswear. I also began to understand that press advertising would be far more important than it had been for us in Europe.

I had to return to England with a plan, which increasingly was based on the way we had approached France – hanging garment delivery by airfreight invoiced in US dollars and including all customs clearance charges. We would need a New York import agency to bring the goods in on our behalf and arrange the onward shipment to customers. The missing element was a sales agency covering the whole country and willing to work on what for the time was an unusual way of doing business. During my travels I had also been looking at American clothing manufacturers as possible partners instead of using purely sales agencies. I was looking for someone with a dealer list

I would like to have for Burberrys. I knew it would not be easy and my first shot would be at Louis Roth the very next day.

Their factory was in the old downtown area on Flower Street so we had booked into a nearby Holiday Inn. As I unpacked my bags, there was a tap on the door. I opened to find a nicely dressed young lady, who, with a smile, asked if there was anything I required. I thanked her and said I was very tired after a long drive.

I had read that the people of southern California were very friendly and was glad to find it demonstrated by my very first encounter. During the night I had a very vivid dream that I was back in London travelling on the Underground. On waking I discovered the 'Underground' had been a severe earthquake. I quickly ran down the stairs and out of the hotel. Looking up, I saw a large crack in the wall above the entrance. Tony very soon joined me.

'Where's the best place to be in an earthquake?' I asked.

'Piccadilly Circus,' was his unhelpful reply. I felt sure it would be safe by a beach thinking we would be better on sand than cement. We transferred to Marina del Rey yacht harbor and the hotel of the same name – a big improvement over the old downtown district. Harry invited us to his home and then out to dinner with his wife. Driving in his Jaguar up one of the canyons, he stopped on a hill to look over at the lights of Los Angeles. I had seen the view featured in films but the real thing was thrilling. After such kind hospitality, I wondered how Harry was going to react to my proposals about the future of the contract.

Arriving at the factory, it was quickly apparent the quality of the clothing was outstanding and fully justified the high prices. Lightweight fabrics and brighter

colourings were the immediate impression. However, by now, after my time in New York, I could see that this was Sunset Boulevard and not Madison Avenue.

It was 1970 and California, on the far side of a vast continent, felt like a different country. In the New York I was beginning to know, meeting for lunch was often in private clubs such as the Harvard, Princeton and Metropolitan, very much the same ambience as around Pall Mall or St James in London. 'Ivy League' style defined a social background and was regularly encountered in resorts from the Hamptons to Newport during the summer season. Echoes of Gatsby once again. Although the clothing manufacturing industry was predominantly Jewish, the look was known as 'WASP' – White Anglo Saxon Protestant. The styling for tailored clothing featured a soft natural shoulder line with very little waist suppression. Worn with Oxford button-down shirts, it was best exemplified by Brooks Brothers. The one-piece sleeve original Burberry cut seemed to fit naturally with this style of dress. Coming from a country with more than an abundance of snobbish attitudes, I soon learned to read all the social indicators. I had no hesitation in deciding the direction to take. It was not west to California.

Harry could see no advantage in my proposals and I felt he was amenable to a quiet dissolution of the licence, at the same time kindly allowing me time to look for other options. I needed an Ivy League-style clothing manufacturer willing to market, alongside his own, the Burberry imports on a commission basis. This would reduce his selling expenses while we handled the importation. In addition, he could have the right to use the Burberry label

on a royalty basis to extend the market for his clothing. The problem was the small amount of import business.

It was back to the telephones again. I was thinking of Southwick as an example but the potential companies were very few and the calls bore little fruit. I had a spark of interest from the Friedman Company of Boston. Milton Friedman was willing to hear my story mainly, I thought, out of curiosity. He had to cancel the meeting at short notice but asked me to see his General Manager at the factory in deepest Brooklyn. I went with Tony and on arrival went into my now very well rehearsed proposal. The manager listened in silence and asked no questions.

At the end he said: 'Thanks, but we would not be interested.'

After I was no longer with Burberrys, Milton came to see me in London. He told me: 'You know that missing that meeting with you all those years ago was the biggest mistake of my life.' He was a very nice man with 20/20 hindsight.

Back at the Louis Roth office, the secretary told me that Fred Pressman from Barneys had called three times and wanted to speak urgently. I was tired and rather depressed, but Fred was very enthusiastic that I should call a Norman Hilton, someone I had never heard of. It turned out that he had been the first business partner of Ralph Lauren and had been financing the manufacture of the very first Polo tailored clothing, all of which meant little to me at the time. Fred said they had had a serious dispute and the Polo clothing was now moving out elsewhere. Hilton might be looking for a possible replacement.

I found out that Hilton Clothes was a well respected family owned business in Linden, New Jersey. Their

biggest customer was Brooks Brothers, which was recommendation enough for me. I put in a call to Norman who invited me to meet him for lunch at the Princeton Club. Naturally.

11

BACK IN THE U. S. OF A.

NORMAN HILTON was aged around fifty, dressed in typical WASP style and a typical WASP Anglophile. I looked more closely at his navy blue blazer with its classic American soft shoulder combined with an English closer body fit. It was an interesting Anglo-American look. I laid out yet again my proposal and was met with the familiar blank look. I was obviously still doing something wrong so I asked Tony, now a resident New Yorker, to try again. This at least drew a reply:

'I haven't understood exactly what you two want, but I'm going to be in London in two weeks buying fabrics and maybe we can talk again.'

This was progress. Wishing to understand was better than a flat-out refusal.

We duly met at the Haymarket showroom and I took him on a tour of the store.

'Why didn't you say that this is what you were talking about? We can really do something with this.' For the first time I had achieved a breakthrough.

We went for dinner at the Connaught that night with my wife and Norman's merchandise manager to celebrate a tentative agreement. They had the right customer list for us with salesmen across the country. Suddenly there was a slight tremor and what sounded like an explosion not too far away. The IRA had set off a bomb in nearby Oxford Street close to Selfridges. Welcome to London!

I had a degree in foreign languages and it seemed American had not been one of them, but I had now learned my lesson. In France where discussion is something of an art form, I was accustomed to outline a given problem and by moving in logical steps finally arrive at a conclusion. QED. America was the exact reverse. You start with the conclusion! I should have shown photos and said: 'We are setting up a sales organization to market the merchandise we are importing. Here are some photos. Are you interested?' Details to follow.

Harry agreed to terminate the licence and Burberrys moved into part of the Hilton showrooms in the clothing market building at 1290 Sixth Avenue.

Tony had already had another success in persuading Bloomingdales, who had their own import facilities through AMC, to try a dozen ladies' trench coats. It was a new style I had made up by altering the pattern of the original men's fully cut one piece sleeve Trench Warm of 1915 so it would fit a woman. The result was unusual but also striking – on the right woman.

Bloomingdales at this time, before it was merged into the more impersonal Macy's group, was by far the most fashionable of all the New York department stores. The coat buyer, Bruce Morrison, was leaving on a buying trip to Europe and planned to come in to see me. I had invited

him to dinner the night before. He was a little late to join us but I saw him come in waving a piece of paper:

'I've just had this telex. Your coats were delivered and sold out right off! We need to talk seriously tomorrow.' It was the start of a productive relationship.

It was the beginning of the Fall season. We agreed joint advertisements and the factory moved very quickly. Our coats were in Bloomingdales and selling in quantities. This provoked an immediate clamour from all the other Manhattan department stores wanting to place orders, but I realized this was a lucky chance in a tough market. I decided to refuse them all and instead work closely with Bloomingdales to give them a whole year start over the rest. The results made Burberrys overnight into an important supplier with ladies' department stores. The lack of an equivalent of our type of men's specialty store catering for women meant that the department store route was the only way to volume sales.

The following year we began to sell every better class department store up and down Fifth Avenue, such as Saks and the late lamented Bonwit Teller. For the first time in his life Norman Hilton found himself in the womenswear business. He polished up his charm and began to entertain lady store buyers to lunch at La Grenouille, an experience he likened to 'eating chopped hundred dollar bills'.

My interest in the original Trench Warm began when Barneys bought it in their first order. Until then not a single piece had been sold in Europe and Haymarket would not stock it. Barneys took the coat complete with the original full robe camel liner with sleeves and detachable collar. It was very heavy and extremely expensive, but nobody in New York could ever have seen anything like it.

Then I noticed that their black customers were wearing the coat with the loose camel collar worn on the outside, creating a whole new look. I asked for the design department at Chatham Place to alter the pattern so that the coats could be delivered with the camel collar buttoned in place. The style was known as the Trench 21 and became the Burberry signature coat in America. Haymarket were forced to stock it when tourists began to ask for the specific style. Using the same idea to produce a new Trench for ladies, but omitting the heavy liner, led to our success in Bloomingdales. All because of some old catalogues saved from a fire.

Norman had by now made his first visit to meet the team at Chatham Place and chose not to come empty-handed. He brought his first order with him. It was for two hundred and fifty men's coats for Saks Fifth Avenue. Our importation system was working very smoothly and I was now beginning to feel more secure about the future when Aquascutum involuntarily did us a big favour. They opened up a factory in Montreal to serve not just the modest-sized Canadian market, but more to supply the USA. The close proximity across the border and the very favourable terms of trade between Canada and the US no doubt made sense. We, however, could now promote Burberrys as the only authentic English coat imported from Britain, which would become the basis of our future advertising.

We had made little use of press advertising in Europe. Languages could be a problem and we had concentrated instead on target city shows. We had left J. Walter Thompson in favour of a small agency of bright and eager young people, but since I hoped to devote our entire

budget to an opening campaign in America it seemed prudent to wait until I could carry out some market research.

Around this time the Ralph Lauren Polo brand began to appear in good class retailers. Their clothing, with its soft shoulders and body shaping, mixed with colourful ties and shirts, brought new life to many traditional stores. The Polo high prices helped to loosen the tight grip a WASP often held on his wallet when purchasing clothing. This upward price trend was a great help to Burberrys.

I had a lot to learn about the USA, a country much less familiar in 1970 than today. It was usually divided into regional markets centred on a city – east coast New York, southeast Atlanta, south Dallas, midwest Chicago and the thirteen western states Los Angeles. The cities had either an established clothing market area or held sales conventions for buyers visiting from out of town. I found it easier to think of them as five separate European countries. The differences between them were often every bit just as distinct.

Sharing the Norman Hilton customers gave us an immediate introduction across the vast country and gradually began to bring results. Hilton Clothes of Linden New Jersey was family owned and well respected, if not so well known outside the tailoring trade. The head of the business was Billy Hilton. Norman and his brother John were nephews. The strength of the business was private label contractor work and the main customer was Brooks Brothers. John looked after this part, but they needed their own label – Norman Hilton – the clothing collection, with which Burberrys joined forces.

Norman would often lunch at 21 Club and stay at the New York Athletic Club during the selling season. He was a regular member of the Princeton Club and aspired to an 'old money' image. John was very different. Tall and slim, he was a regular eight Martini (I counted) lunch man with a lightning wit. I had been out to the New Jersey factory with John, Norman and their accountant for a meeting with Billy about Hilton Clothes licensing the Burberry label. We reached an agreement although it was clear Burberry would only be a second label after Norman Hilton. I was not too concerned as this was not the primary objective. The factory was closed and It was dark when we came out of the back door.

The accountant, who was Jewish, stumbled and fell over a pile of trash.

'You keep this yard like a pig sty,' he complained as he got up.

'Don't worry,' said John. 'You know pigs don't eat Jews.'

Even the accountant laughed.

Norman held a cocktail party to celebrate the opening of the new Burberry showroom. It was rare for lady buyers to be present in the menswear building and when John arrived, visibly drunk, his eyes lit up at the surprising sight of smartly dressed ladies. As he swayed in their direction, Norman headed him off and had him quickly and quietly ejected from the room. Just in time.

I visited all the markets even if some were less than ideal for raincoats, but the Hilton connection always knew the right stores. These were retailers, though located in the sunbelt, with very wealthy customers who travelled a great deal and needed the appropriate wardrobe.

However, the Deep South was a very different world in 1970. At a dinner party in a Georgia country club, a man asked what I thought about the war. I tried to think of something tactful to say about Vietnam when I realised he was talking about the American Civil War. All the club staff and waiters, wearing their white jackets and gloves, were dignified and quietly spoken black men. Impassive, they seemed silently to materialize when summoned by club members.

After a week on Sea Island, we took the short flight back to Washington DC. We went out to dinner in a nice restaurant – not a country club. After Georgia, it was a shock to see smartly dressed black diners being served by white waiters!

I began to learn how very different America was in so many respects compared with my European experiences. National drinking habits are always useful indicators and in the seventies my impression based on New York showed a decided preference for hard liquor in the form of cocktails. In contrast to the cosy English pub, American bars were very professional and bartenders knew how to pour heavy! An invitation for 'a drink' did not mean a nice dry sherry. John Hilton was by no means exceptional when cocktails continued through lunch or dinner with a happy disregard for wine. 'Wine is fine but liquor is quicker' seemed to be the general maxim.

After my travels on the continent, I found this unusual until Fred Pressman told me of his regular irritation on buying trips to Paris. He liked to order his preferred Scotch to accompany his steak and was often met with a question and surprised disdain. Eventually the appreciation of fine wines, especially from California, began to

spread, but at this time wine was often associated with cheap alcohol for down-and-out winos. Beer was more of a blue-collar drink served in taverns.

Americans seemed able to consume large quantities without becoming ugly as is all too often the case in England. Norman Hilton from time to time felt the need to take a break from his drinking. Unfortunately, he was great fun when he was drinking but very much less so when off the drink. He and his wife Connie were on a flight back to New York from their vacation home on Sea Island Georgia. He had named the house Polo after selling the shares given to him by Ralph Lauren to buy out his share of the Polo business. Originally they were almost worthless, but with time the unlikely shares increased greatly in value and Norman was able to use the money to buy an ocean front home in an exclusive location. When the flight attendant came to take the drink orders after take off, Norman declined, which prompted Connie to ask: 'Norman. Did you understand the question?'

On a visit to a Philadelphia clothing factory I was invited out for a drink in a nearby bar by Mike the factory manager. He was a very friendly, stocky Italian-American wearing his hat. I was impressed by the general quality standard of American tailored clothing and, with the exception of Italy, I thought it superior to most similar European clothing. America had long benefited from immigrants from southern Italy. They brought with them their hand tailoring tradition which I thought showed in the character of much American clothing.

I asked Mike how he managed his labour force as the Italians moved up in society to be replaced by new immigrants from Latin America. He explained that he

promoted Italians to fill all his section management positions. It was a cold day not long before Christmas and I asked him what he was doing for the holidays.

'We usually go to my wife's family. It's a bit quiet as they don't drink. They only have wine.'

Before we parted he said he wanted to take me for a ride to show me the family home where Grace Kelly used to live. A visiting Englishman might have a queen, but Philadelphia could claim a glamorous princess.

Throughout the seventies the return of Burberry to the USA brought me very regularly to New York. The office at 1290 Sixth Avenue was conveniently located and almost everything was within walking distance. Constant honking horns of the yellow cabs crawling in slow-motion traffic jams created an unending soundtrack. In summer the 90 per cent heat and matching humidity made for 'two shirt days', yet the air conditioning turned every interior into a meat store.

I loved the cold clear days of fall when around five o'clock a brilliant dark blue sky illuminated the end of the long avenues as office workers streamed out of the tower blocks. Clouds of steam rose up from vents in the streets and the roasted chestnut sellers brought out their charcoal braziers on street corners, but winter could bring surprise blizzard snowstorms. I was staying at the Plaza and a friend was visiting from England. We had planned a visit to a jazz club when, with the arrival of heavy snow, the city shut down around six o'clock. It was impossible to go out and my friend had to stay the night. The hotel's Oak Room restaurant soon became packed with similarly stranded guests, including some well-known personalities.

Fortunately, I had changed from the more spartan Harvard Club, which I had found to overly resemble a boarding school for grown ups.

Jazz was my obsessive interest and in New York, the jazz capital of the world, I was able to see in real life names I had only known from record labels. I had been to most jazz venues in the city but at this time jazz, already considered an art form in Europe, was more a part of the night club entertainment business in America. It was sad sometimes to see a gifted musician playing through the loud chatter of an uncaring crowd, but the popularity of jazz in the 'sixties was in decline as the 'seventies ushered in rock music. I had read about a jazz museum where Charlie 'Bird' Parker's alto saxophone was exhibited. I arrived at the location only to find it had been turned into a sleazy porn cinema. Bird had always had bad luck – even posthumously.

I learned more about jazz in America when Tony and I went to see Miles Davis. A slight and unsmiling figure with dark glasses, he was rehearsing a new band featuring electric instruments for the first time. It was a dark crowded basement and we were the only two white people. The atmosphere was not very friendly and not helped by the lack of any announcement during a long non-stop set. The new music was exciting, but we left as soon as it was over.

Shortly after, we went to a bar in the Village to see Al Haig, a superb pianist and a favourite of mine since hearing him on the first bebop recordings in 1945 with Dizzy Gillespie and Charlie Parker. Tony and I were wearing our usual Burberry trench coats and as I went up

to say hello, Al's first words were: 'Are you from the police?' It dawned on me that two white men in identical trench coats might not have been an ideal wardrobe choice for jazz, especially when a mainly black audience was present.

I had to thank Barneys for my first start in New York. Barney Pressman had begun as a dealer in bankrupt clothing stocks, but Fred, his son, had built it into perhaps the best store in New York. He travelled to Europe for new and exclusive labels from Italy and France, and he was the first American retailer to stock the newly revived Burberrys. Barney still came into the office, but with little to do.

He seemed rather lonely and one afternoon he invited me for a drive in his limo, complete with uniformed black chauffeur. As darkness fell, we were driving through Central Park as the lights came on in the windows of the surrounding tall towers. Barneys was a classic American success story, but America had been good to me too. And I never met an American who wanted to emigrate.

12

A Little Detour into History

I NEEDED to find a focus for advertising in the USA. What was so special about Burberrys? It had to be something simple. American advertising was fast and direct, so an obvious choice would have been the House Check. However, its bold design could become overexposed and easily copied. Plus, it was not registered.

I thought once again about the success of the Burberry Trench coat at Barneys. The style had not been promoted by the Burberry New York operation during 1959/60 when I was very much involved. Why was it now so much more popular in the America of 1971? It could be the influence of Hollywood revived with the advent of television. Macho private eye characters in trench coats were everywhere in the many popular crime series. I started to search for Burberry coats worn in old films and came up with Robert Taylor and Victor Mature, but I was really hoping to turn up Humphrey Bogart as the archetypical trench coat-wearing tough guy. A search found no pictures of Bogie in Burberry, but I found one of him wearing an Aquascutum Trench. Not helpful. However, there was one

important British example – Peter Sellers as Inspector Clouseau. I loved it but it was hardly the right image to promote the Burberry Trench in the USA. There would be any number of Burberry Trench coats in Hollywood films but only after Burberry adverts had appeared. The cinema connection was not going to work and there would no doubt have been copyright issues if used in commercial advertising.

The next thought was to see if Burberrys could have invented the Trench coat.

The first Burberry advertisement for the Trench was from 1916. I needed to see when anything equivalent was on the market and went to visit the Imperial War Museum. The staff suggested I examine the *Illustrated London News* and similar periodicals for the period 1914/15. By the end of 1914, the slaughter of the first cavalry charges led to a static war of attrition conducted from two opposing lines of trenches along the Western Front. A type of coat adopted by British officers, who had to select and buy their own kit, soon became known as the Trench Coat. Combing through the magazines from 1915 revealed that a 'Trench Warm' was advertised by several companies, including Dexter, Thresher, Aquascutum and Westfield. All provided the very same camel fleece detachable robe liner as Burberry and some even had a fur lining. The only style difference was that most of the coats were with set-in sleeves rather than the usual Burberry raglan.

A search in the Museum photo archives of British troops in France failed to produce a Burberry Trench. On the other hand, the original Burberry 'Walking' style 'approved by the War Office' in 1906 appeared popular

with officers, as also did the 1910 double-breasted Burberry coat, as worn by Field Marshal Lord Kitchener. This only needed the addition of epaulettes, sleeve straps and other accoutrements to become the full Trench, if so desired by the customer. I went on to study photographs of the first American troops arriving in France in 1917. These appeared to show that a Trench coat was standard army issue for the US officers. How did that happen?

I had to conclude that the Trench had evolved by practical circumstances into a generic military style together with the British Warm short topcoat in woollen Crombie. It was clearly not possible to claim authentic provenance, but nor could anyone else. I decided that the Burberry name could safely be 'associated' with the birth of the Trench coat and then leave it for the imagination and mythology to work. Lawyers' words perhaps, but this was for America.

13
GETTING TO KNOW YOU

A NEW Burberry store was opened in 1971 on Avenue Louise in Brussels and the continuing expansion of the Retail Division helped to increase manufacturing to the point where we were beginning to use contractors. The Regent Street store proved the value of windows on a busy street in close proximity to Aquascutum and Austin Reed. Haymarket carried on in a sadly declining location and the Wholesale showroom now also moved to Regent Street.

Moving into the 'seventies, I felt that Burberrys advertising lacked a memorable campaign such as 'The Man in the Hathaway Shirt'. Much fashion advertising still featured stiffly posed unsmiling models in sterile studio settings reminiscent of Cecil Beaton in *Vogue*. A new school of young fashion photographers had by now introduced a complete change of style, but their identification with 'swinging London' was not what I was looking for. I had attended agency presentations and one was much like any other, although perhaps a presentation could only be as good as the company's briefing. All the usual magazines

were sent to the office and I took them home, mainly to study the advertisements. Leafing through *Harper's Bazaar*, I came upon a feature right at the back of the magazine entitled 'Jennifer's Diary'. It was a small section of society gossip about the upper classes at play in gatherings illustrated by small informal and slightly amateurish photos. Hats, dogs and horses usually played a large part.

Like a flash, it dawned on me that this might just be the unlikely way ahead. I called in the agency to put forward my ideas – no fashion photographers, no professional models and only informal, real-life locations – a commercialised version of 'Jennifer's Diary' with a photo journalist approach. The briefing was highly unconventional and the agency were rather quiet. They asked for time to think about it before meeting again in a few days. And then they came back with a brilliant proposal – the photographer Patrick Lichfield, a.k.a. the Earl of Lichfield and cousin to HM the Queen! Could this be The Earl in the Burberry Coat?

It turned out to be better than that. I was only slightly aware of Lichfield as a glossy, chocolate-box photographer of society and Royal Family portraits, but his style applied to fashion might work out well. My original brief began to take shape when he offered the grand family seat of Shugborough Hall as location and six of his personal posh 'chums' as models. One of them later turned out to be his sister Lady Elizabeth Anson. Terms were soon agreed and I invited the 'models' to come to Haymarket. They made their own personal selection, up to an agreed sum, of any outfits suitable for a weekend in the country. Their choice was not important for what I had in mind, but I asked them to wear the clothes regularly before the shoot for a

lived-in look. They were to bring their own accessories and we would add a few Burberry scarves and umbrellas. They were pleased to be paid in expensive clothes but our budget was based on the much lower cost prices i.e. £100 retail = £40 cost.

It was to be a two day shoot at Shugborough and the agency said they would not attend. They thought it better that I oversee this first experiment since I seemed to have a clear idea of what I wanted – in other words, 'If it all goes wrong, don't blame us.'

I was invited to stay the night before but I was late leaving Hackney and ran into heavy traffic heading north out of London on the M1. I was almost an hour late arriving and by now darkness had fallen. I found the entrance into the grounds of Shugborough, but it was pitch black with not a single light showing.

My headlights finally illuminated the front of a very large building with a broad flight of steps leading up to a row of columns. Although no habitué of stately homes, I hardly expected a front door and bell push, but how do you get in? With the illumination of my car headlights I mounted the steps and found a pair of the most enormous doors looking seriously shut. My knocks produced no response. I drove round the side of the house and glimpsed a faint light coming from a small door. My loud knocks finally produced a cook in full chef rig. He looked very doubtful when I asked for Lord Lichfield at what was the kitchen door. He told me to stay where I was. Soon a butler arrived to check my identity. He then took my case as I made my undignified entrance through the kitchen. He led me upstairs to my room and, very conscious of my late arrival, I threw the case on the bed and had a rapid

wash and brush up before finding my way downstairs. The house belonged to the National Trust, but Lichfield retained a suite of 35 rooms for his private use.

After I apologised for my late arrival, we were soon a convivial party of eight. Everybody else knew each other and I had met them at the Haymarket when they chose their clothes. The food was excellent and Lichfield was an entertaining host with an endless stream of very amusing anecdotes. At times the sound of dropping names was almost deafening, but a little malicious gossip goes a long way as amusement. I was tired and went to bed leaving them to their digestifs. As I entered my room and switched on the light, I saw my suitcase was gone. After a moment of panic, I remembered that this was not some Holiday Inn. Of course! Everything was neatly folded away in the drawers and my toilet kit laid out in the bathroom. I felt what it must be like to be Prince Charles.

Morning brought a sunny day for the photography. Over breakfast, I told the 'guests' to do whatever they would normally do on a country house weekend. There were Range Rovers, Labradors and a lake with a rowing boat and they ordered a picnic to take out on the estate. Lichfield followed them around with a small 35mm camera shooting a succession of what looked like any family holiday snapshots, but he asked them not to look at the camera. I wanted him to be in some of the shots, to which he agreed. He placed the camera in position and then his young assistant, 'Chalky' (naturally), would just press the shutter.

Everything was going as I had imagined, so I left to return to London. We met shortly after with the agency. Many rolls of film had been shot and were now for

viewing through the lightbox. First impressions showed many were awful, but a closer examination revealed that just a few were excellent: enough for what I was looking for.

We decided to spend the entire budget on just one American magazine in the belief that it was more effective to be dominant in one place rather than scatter the message. I pushed for the *New Yorker* and we booked eight full-colour pages to run every second week through the Fall season. The sole text was in small letters across the bottom of the page stating –

'Lord Lichfield and friends on his estate. Photography by Lord Lichfield.'

At last, we had our identification. The success was immediate and even greater than I had hoped for. I knew this because Burberry Trench coats became the most copied style in America as all of Seventh Avenue rushed to grab their cutting shears. Needless to say, the prices were lower, but so was the quality.

A campaign focused on one individual must of necessity have a finite life but the results from the Lichfield advertisements were so successful that I estimated a life of perhaps three years. I began to think about a future major show in New York with Lichfield in person while the campaign was most effective. Meanwhile we continued to open new accounts, introducing us to an ever wider audience.

Lichfield was extremely pleased at the huge increase in his profile in America and when it became clear the campaign was a long-term project, we were soon on first name terms to the extent that he kindly invited my wife and me to his forthcoming wedding in 1975. The future

bride was Leonora Grosvenor, a daughter of the Duke of Westminster, a man said to be very comfortable.

The ceremony was at Chester cathedral and the reception at Eaton Hall – two stately homes in just two years! To my wife's irritation, I opted against formal dress only then to discover on arrival that I was the sole man to have so chosen. Luckily, I spotted just one other hardy individualist – Kenneth Tynan, theatre critic of the *Observer* and famous at the time as the first person to use the word 'F***' on live television. In the marquee following the reception line, the Royal Family had fielded the full first eleven, ably captained as usual by HM the Queen. I had a momentary vision of much bowing and curtsying in all directions, but it turned out to be a relaxed and pleasantly normal family occasion.

The advertising in America began to solve a difficulty we had with many high-class retailers. Their 'private label' policy, like Brooks Bros., meant that their merchandise carried only the store label. This had the advantage of avoiding price comparisons and gave an impression of exclusivity. Such eminent retailers were to be found in every major US city and appearing in their stores was our objective. However, since we were equally unwilling to supply them without the Burberry label, a state of impasse had arisen.

Norman Hilton was thoroughly familiar and well connected with this market. He was identified with the modern Ivy League look and Hilton Clothes supplied tailored clothing to many of the private label retailers, but their relationship with Brooks Bros. in tailored clothing was of no help to Burberrys. Our prices were notably

higher than the Brooks rainwear, which they imported from a small specialist maker in Yorkshire. Advertising was the key to unlocking this market.

The Lichfield campaign was aimed at these exclusive retailers. We hoped their customers would demand the Burberry brand and a refusal could lead to them buying elsewhere. An example was Carroll & Co. of Rodeo Drive in Beverly Hills, at this time still a pleasant small-town type street with some interesting specialty stores. Dick Carroll was a New Yorker who had worked at the Warner Bros. movie studio before opening his store in 1949. His Hollywood connections soon brought names like Fred Astaire, Cary Grant and James Stewart as customers. He had introduced the natural shoulder style to Los Angeles and worked regularly with Norman Hilton. Burberry soon became the exception to his private label policy and from then on many of the Burberry coats seen in films came from this store.

Dick Carroll was influential in promoting Rodeo Drive as the elegant location in Los Angeles and, with other retailers, opened the street's restaurant, the Saloon.

These efforts triggered the law of unintended consequences when Rodeo Drive began to attract international names such as Gucci and Hermes. The result was to drive up rents to a level which would eventually oblige Carroll & Co. to move out of Rodeo Drive in 1996 to a less costly location.

14
DESIGNERS – STYLISTS – TECHNICIANS

W HAT IS a designer? Back in 1856 Thomas
Burberry was no designer. He was a small
town country businessman who invented
a method of weatherproofing cotton fabrics. He named
his fabric 'gaberdine' and his attempt to register the name
unsurprisingly failed. A more promising step to promote
the fabric was to utilize it in the form of a raincoat carry-
ing his name. Simplicity of style and cut was his approach.
A range of other functional clothing in the same fabric
soon followed, some being adopted by the military. The
opening of a London shop by the end of the century
marked the beginning of international success and his
name entered the Oxford dictionary as a synonym for a
raincoat.

Does this make Thomas Burberry a 'designer' – or was
he rather an inventor and entrepreneur? I was about to be
called upon to debate the question after a phone call from
an old friend. Anne Tyrrell graduated from the Royal
College of Art and was now running her own design
studio supplying the womenswear trade. In addition, she

was a part time lecturer at the RCA fashion school, where she might spot promising students to join her business. I was surprised when she asked me to help assess a group of final year students. Although Burberrys was by now an important manufacturer and large-scale employer, I would not have thought there was any obvious association with the Royal College of Art.

I was even more surprised when I found my co-assessors were two charming ladies, namely Mrs Joan Burstein of Browns and Mme Missoni of Italian knitwear fame. I felt literally the odd man out. The students all produced some excellent sketches but drawing, if not directly related to a specific fabric, can often lead to superfluous detailing. Clothing has a practical function, including the buttoning, and I was not sure that all of them could cut a pattern and turn a sketch into a well fitting garment. Judging their creativity in purely fashion terms was an area where I could not help, but I wondered if they understood to what extent their talents would soon have to adapt to industrial and commercial demands.

We met with the principal to discuss our assessments. The two ladies were full of praise, but I felt that two of the students had failed: one for poor attendance and one for poor technical ability. The room fell very silent. The principal went into a vague discourse from which I gathered that failing a student was not the done thing. I wanted to say that an employer would expect some indication of ability and for all applicants to be judged the same was not helpful. However, I decided to let the moment pass. After all, Anne was a friend.

I recognized the importance given to artistic imagination, so to end on a positive note I invited the group

to Chatham Place to see at first hand the workings of a clothing manufacturing business. I offered them to select from the cloth store some lengths of fine quality fabrics that students might not be used to working with. My only advice was that fine cloth quality benefits from simplicity of cut, thereby allowing the fabric full expression to speak for itself.

They had seen the design room function as primarily providing updated cutting patterns for the various factories adjusted for regular changes in manufacturing methods. This was typical of most clothing companies and I was not expecting a rush of applicants. Maybe a glimpse of real life might caution against dreams of news-hungry fashion journalists constantly claiming the discovery of the next great British designer. I wondered how many of these 'discoveries' go on to run businesses making significant money. Surely, a serious gap in the syllabus?

I hoped the students had understood that 'designer' could be a confusing description. The head of design in Burberrys was not a designer in their terms.

Design applied to the manufacturing process might have better employment prospects than pure fashion design. Burberrys did not offer entirely new collections twice a year. Meetings held each season usually resulted in minor adjustments to key garments but added only a few completely new models.

Although fashions for women might originate in Paris, the concept of outright fashion design for men emerging in London in the 'sixties produced some quite frightening results – all the more so seen in retrospect. The subsequent gradual debasement in the use of the word 'designer' – with examples such as 'See our award-winning designer

sunglasses' − means that it now implies something cheap and best avoided! Similarly, the term 'designer jeans' sounds tired and outmoded.

In the nineteen-thirties, Burberry brochures showed a small number of models but a very large selection of fabrics. A 1935 leather-bound collection of raincoat patterns for those few styles has more than one hundred different cotton fabrics from the company's mill. There was a similar wide choice of woollens, all with intriguing promotional names for different fabrics, but again offered in just a few styles, often based on the Walking pattern. For garment manufacturing this emphasis on fabric innovation over styling offered very obvious efficiencies.

Talking with the students about the function of design helped me to clarify my ideas about brand development applied to clothing. Sitting in a jet at 35,000 feet over the Atlantic and looking through the window to see the Rolls Royce badge 'RR' on the side of the engine gave me a feeling of great assurance. It was an example of a priceless asset developed consistently over a hundred years of engineering excellence. In a similar way, 'Heinz baked beans' is a brand, while 'Tesco baked beans' is a label. Labels are for identification whereas a brand should stand for something recognised as the best in its category. A label only becomes a true brand when the product alone identifies the producer. Thomas Burberry's artisan practicality achieved this with a product which grew into a brand worthy of entering the national dictionary.

Referring to a footballer as a 'brand' is lazy linguistic nonsense very typical of the fashion industry's use of language as sound without meaning. Modern media has created a category of celebrity designers catering to

consumers wanting an easy way to identify with their lifestyle and status. A T-shirt can suggest style cachet by printing a motif on the chest. But it is still just a T-shirt. By the same token, I had similar reservations about the Burberry House Check, but it is a very rare example of consumer demand pre-empting the company's intentions.

The main lesson I took from my discovery of Burberry pre-war publicity was eliminating the complete re-design of perfectly satisfactory garments when a simple change of fabric could provide an infinite variety of new colour and texture. For this, I was grateful to Robert Sundler, the fabric buyer, for passing on to me so much of his knowledge of textiles gained since he joined Burberrys in 1929.

I concluded that design for a well-established brand has to be a part of marketing strategy. Design alone, however brilliant, can reduce a brand to a 'designer' label with merchandise only identifiable by reference to the label. Like a reputation for quality, a brand's authenticity, once lost, is not easily regained after it has become dependent on the outcome of critical reviews every six months.

15
HAPPY ECCENTRICS

W
ITH THE introduction of polyester the basic raincoat fabric was a 50/50 blend gabardine readily available in the textile industry, but the traditional Burberry all cotton yarn dyed fabrics were difficult to source after the company mill was closed. The change from waxed yarns to silicone piece proofing was a welcome technical advance in some ways but it changed the distinctive character of the cloth. The cotton industry seemed lacking in technical advances and after much searching, we finally found a very competent supplier in Belgium willing to undertake yarn dyed manufacturing in return for guaranteed quantities.

For all other fabrics, British mills had everything we wanted, from cashmere and camel to West of England coverts, Donegal tweeds and Scottish Shetlands.

The main supplier of the last was Hunters of Brora with their vast selection of yarn colours, also featured in the finest Shetland knitwear.

I had visited many Scottish mills and was impressed by their business-like attitude, but always looking for

different sources, I was interested when a friend from Aquascutum, Tony Boeg, told me he was moving to Ireland, convinced of the possibility of producing cashmere at more competitive prices than Scotland. I had never been to Ireland although part-Irish, but provided with his list of some small artisan weavers I set off with enthusiasm and booked into the Arbutus Lodge in Cork. The town was most attractive with excellent food, especially in nearby Kinsale. I was very impressed, but after doing business in Scotland, I was not quite prepared for the more relaxed Irish attitude. On arrival at my first appointment I was greeted with: 'Let's go down to the pub and we'll have a talk about what you're wanting.'

They had some attractive tweeds but the air of happy disorganization was not encouraging for a reliable supplier connection. I took a few samples but then became hopelessly lost on the narrow country roads on the way to my next appointment. I stopped to ask the way:

'I see you're in a hurry, but it's only three miles and you'll be there in no time.'

I was relieved until I saw the next signpost frustratingly indicated eight miles.

Along the drive I was struck by the Irish fondness not for picturesque cottages of the tourist brochures but rather their predilection for dull brick-built bungalows. Almost all featured signs on the road advertising an unusual variety of articles for sale. I think my favourite combination of offerings was the surreal:

'Rabbits and cement.'

After a late arrival at my hotel in Galway I ordered next day my breakfast served in the room. A cheerful young girl

carried in the tray and I asked her about the constantly changeable weather. With no hesitation she reported:

'It's a beautiful day today sir.'

I opened the curtains and it was raining.

My final appointment was back near Cork where I was to meet the mill designer.

A rather rumpled figure came in and I asked him to send for the designer.

'I'm the designer,' he said, pulling from his numerous pockets a large selection of wool yarns. We set to work devising new colourways and I left pleased with the results after placing my orders.

When the fabric was delivered it was not at all as ordered, but since there was no time and it all looked very attractive, I had it manufactured and sent out anyway. Surprisingly, the customers must have been happy and we received no complaints, but I was not sure I could afford to take similar chances in future.

Before leaving Cork I went to Blarney castle to climb the tower and kiss the famous stone. I was promised it would bring me the gift of charming speech.

Obviously, everyone else had already done so before me, so I knew it should have been my very first act in Ireland rather than my last.

I had enjoyed the trip but the Irish textile industry required more time than I had available. Tony Boeg had to abandon his ambition of manufacturing Irish cashmere and wisely opened instead a clothing store in Cork selling typical Irish clothing and Arran knitwear. He named it House of Donegal.

Another eccentric enthusiast for all things Irish was Serge Tchistiakoff in Paris. As the agent for Burberry

womenswear in France he had enjoyed a great success with *le style anglais*. His father had been an officer in the army of the Tsar and after the revolution had fled to Paris where he began a new career as a taxi driver. Serge was proud of his Russian descent but his request for a visa to visit the ancestral home in Russia was refused by the Soviet embassy.

With his wife, a former model from Guadeloupe, he opened the Irish Shop in Paris. After his selling season, Serge would travel around Ireland, despite his minimal English, buying for the shop a selection of the same merchandise as Tony carried in Cork. They would often work together with suppliers but I could not help feeling that the typical selection from Ireland was somewhat limited.

Serge was really a perfect Irishman. To attend a party, he rented the uniform of a Soviet general but on the way became involved in a traffic accident. Unwisely he told the police he was a Soviet officer and tried to claim diplomatic immunity. A call to the Soviet embassy led to the obvious unfortunate outcome.

He once invited me to dinner and chose a restaurant in Belleville, an area of Paris I did not know. We parked in a dimly lit side street and entered a small restaurant. It was immediately evident we were the only white customers and somewhat overdressed in our business suits. Serge seemed well known and ordered champagne. There was no menu since only one dish was on offer. The waitress used a word which I understood to mean porcupine. Gestures soon established that this was indeed the case, but I was assured it was fresh, having just arrived by suitcase from Senegal. I settled for salad.

Wishing to be friendly, I asked the young man at the next table what he did. He replied that as an illegal immigrant he had no papers so could not take a job and that all the other diners were in a similar category. At this point, Serge, by now, floating on a wave of champagne, climbed up on a chair and in a loud voice proposed marriage to our waitress. There was a sudden complete silence until laughter broke out on all sides.

I decided it was a very good time to leave. With Serge driving erratically back to town, I said:

'If you carry on drinking like this you're going to lose your licence.'

'Don't worry,' was the reply. 'I've already lost it.'

A perfect Irishman!

16
The Last Campaign

IN THE nineteen-seventies Burberrys' business was drawn almost entirely from Western Europe and increasingly America. Japan readily signed licensing contracts to import foreign technology, but was far less welcoming to any imports its own industry was able to produce. The fall of the Iron Curtain and the economic rise of China were not all that far in the future, but totally unforeseen.

Burberrys factories were now producing a hundred thousand raincoats a year with every fabric option ranging from featherweight poplins for spring up to detachable camel lined trench coats for winter. Only the USA still had potential to maintain this level and a show in New York had to be the next objective.

At the same time, it could already be seen that the increasing development of the Common Market after 1973 was going to bring us competition. It was equally evident that this would come from the quality textile and menswear industry of Italy, just as their womenswear was beginning to challenge the primacy of Paris. Yet Italy

was consistently Burberrys' largest European market and in Milan the traditional English gentleman in his Savile Row suit or navy blue blazer with his Scottish cashmere sweater and Church brogues was considered the height of style. How ironic therefore to observe how Italy eventually became the most important, if not the only, source of fine quality clothing to remain in Europe.

By contrast, so much of the British industry had opted to chase after the mass quantities ordered by Marks & Spencer. I had once observed their method of management. Suppliers would face an arrogant committee, chipping away at quality standards penny by penny, and effectively de-skilling many British clothing manufacturers. The result was anodyne styling, poor colour selection and hopelessly outdated in-store display. M&S had felt no need to accept credit cards other than their own and the complete collapse in their profit performance in the late 'nineties should have been no great surprise. They dropped their 'Made in Britain' policy to switch production to cheaper overseas suppliers. The results were far from satisfactory, but by then British manufacturers had gone out of business with the loss of several thousand jobs. M&S clothing continues to struggle. Pursuing the same failed policies year after year is puzzling.

It was 1976 and I was glad to be back in New York to start planning a big show celebrating Burberrys' return to the USA after a ten-year absence. A date was booked for the Pierre Hotel ballroom to hold a large cocktail reception and sit down dinner show. Norman engaged the top PR lady, Eleanor Lambert, and I undertook the music arrangements. New York always was a very special

place for me. After evening business dinners ended I would head for the late night jazz spots, usually Bradleys of University Place in the Village. It was here I came to know the pianist Al Haig.

It would be my personal indulgence to engage him for the Pierre Hotel show, playing solo for the reception but with a small jazz group adding bass, drums and guitar for the model parade. I felt strongly that a New York show should find a place for the music that America can truly claim as its one original contribution to world culture. On the other hand, I could not help wondering if any of the glittering audience would know they were listening to Charlie Parker's favourite pianist.

The night before the show some of us went out to dinner with Patrick Lichfield, who was to be the show's guest of honour. He had chosen a restaurant so achingly trendy that even with reservations they still liked to make customers stand in line. He very coolly went up to the head of the line and said to the *maître d'*:

'I am Lord Lichfield. I am expecting an important telephone call from London.'

It was the days before mobile phones and we were seated within minutes. I had just learned one more of the many advantages in hanging out with lords.

We had already decided that a New York show required professional services. Max Evans was to produce the show with Eleanor Lambert organizing the event and the press. In addition to Patrick as the guest of honour, the New York British Consul General was also present at the top table. The invitation made impressive reading and the response was excellent.

The guest list was made up of customers, including many from out of town, and the press, but in addition, some prominent New Yorkers were also invited, more out of the Social Register than Studio 54. Eleanor had a good relationship with the press and wisely dispensed with the distraction of the usual professional 'celebrities', famous only for being famous.

I had little time to circulate during the reception. I wanted to check with Max that everything was ready to go in the changing room with the six models we had brought over from London. I recognized one or two faces among the guests, one being the former Burberry USA director Victor Barnett and another was the very distinctive Andy Warhol. He produced a tiny tape recorder and asked if I would give him an interview. However, it was not for my magnetic personality but a direct pitch for an advertisement in a magazine he had just started. Had I known more about him, I would have asked him to autograph the dinner menu.

The show was to start with the end of the dinner service and timed to run for about twenty-five minutes. There were fifty fully accessorised outfits, which Max had divided into five scenes: 'The Most Famous Raincoat in the World'; 'Focus on Shetland Tweed'; 'The Luxury Look'; 'Another Color'; and finally – 'The Burberry Look for Fall 1976'. The 'Other Color' was the navy blue version of the House Check only recently introduced. My role was Master of Ceremonies and after I had introduced Patrick as the Earl of Lichfield, the show and the music began. I had been involved at the inception of everything in the show so the commentary was not difficult. Dispensing with a script, I was fortunately never at a loss for words,

but thanks to the professionals the event went off without a hitch. It achieved its aim by demonstrating that Burberry was back in business in America.

My wife and I had taken a suite at the hotel to act as Burberry GHQ for the show. It was the location for the company after-show party when some of the out of town customers found out about it and joined the celebrations. I was once again very impressed by the American capacity for hard liquor. My wife was equally impressed. Shocked at both the room service prices and the rate of consumption she went out to a nearby liquor store to bring back urgent reinforcements. Next morning we went for a badly needed recuperative walk in Central Park.

Back in London, we were relating all our adventures to Emma, our ten year-old daughter. Her rather casual comment was:

'Not bad for a couple of kids from Sheffield.'

Eleanor Lambert's press release for the show is reproduced below.

BURBERRYS
FALL 1976
First American showing

Although Burberrys has enjoyed a fifty-year relationship with stores across America, this is the first Burberry fashion presentation to be held in this country.

The collection for fall 1976 as highlighted today serves to visualize the quality of instant identification which

almost imperceptibly blends with the British classicism it personifies.

As described by Brian Kitson, managing director of Burberrys wholesale division and host for the firm's premier showing at the Pierre Hotel:

'Burberrys approach to designing is merely to evolve from season to season ; details drop out or are updated, but Burberrys is basically a style and a form of taste in dress with its own discreet signature, distinctive enough to have made it a symbol, and a word in the dictionary.'

Burberrys clothes in America will range from $120 upwards for weather coats, with other clothing at commensurate prices.

Patrick, Earl of Lichfield, guest of honour at the showing, was introduced by Mr Kitson. Lord Lichfield, the well known British photographer, with a wide international reputation, is responsible for Burberrys advertising photography, and is also a frequent model in the pictures he takes and labels 'Lord Lichfield by himself'.' The women's fashion pictures are also taken by Lord Lichfield who chooses as his subjects 'real' young women of aristocratic English country life. Among these have been Lady Annunziata Asquith, Lady Denbigh, Lady Carina Fitzalan-Howard and his sister, Lady Elizabeth Shackerley.

Today also inaugurates a new relationship for Burberrys; Norman Hilton, 1290 Avenue of the Americas, New York, N. Y. 10019, has been delegated American headquarters and national distributor for all Burberrys clothes for men and women, accessories and luggage to be sold in the United States.

CREDITS

men's shoes by Church of London
women's shoes by Rayne
additional accessories by Roberta di Camerino
gloves by Aris

PRESS: Eleanor Lambert
32 East 57th Street
New York, N. Y. 10022

17
THE BREAKUP

THE NEW York Show turned out to be my swansong, as it also was for the Chairman, William Peacock, who retired. I was sorry to see him go as he had always treated me very well. I had never had to ask for salary increases and was allowed great freedom of action.

I had assumed John Cohen would take over as chairman with Stanley as deputy, so I was surprised when Leonard Wolfson, Isaac's son, a man I scarcely knew, took over as Chairman. He had played little part in Burberrys and, other than an occasional visit to Haymarket, had never been to Chatham Place. I wondered if he thought he might prefer to be known as a holder of the Royal Warrant in his role of Chairman of Burberrys, by now a very high profile company with three Queens Awards for Export Achievement, as opposed to being head of a large but somewhat down-market mail order company.

A first intimation of the new regime came about over a car. GUS policy provided that company cars should be written down and replaced every three years. Senior

executives had a choice up to an agreed figure for a British manufactured replacement. Roy Hole put in his application as usual, which came back approved except his request for electric windows as an extra had been deleted. It was an omen of new times ahead.

I attended Leonard's first board meeting at Universal House, the Head Office of GUS in Tottenham Court Road. It was a characterless place slightly reminiscent of the government buildings I had seen in East Berlin. I could even imagine all the electric lights were fitted with 40 watt bulbs.

Leonard was slightly built with a serious manner, the sort of man who, on entering a room, can make the temperature seem to fall a couple of degrees. Isaac had made the money and his son's main concern seemed to be holding on to it. He had a wide knowledge of finance and saw himself as a banker rather than an entrepreneur. He spent a great deal of his time going carefully over the monthly financial statements from all the various subsidiary companies while dictating questions to his secretary. These most frequently were demands for increased discounts from suppliers whose response would be a corresponding price increase. Nevertheless, the secretary would have to telephone around to collect the answers for him. Although he was quietly spoken, I sensed he liked to instil a little fear into subordinates. My general impression was that he was not a very social person and, unlike his father, was not very much liked.

My second intimation of the future arose from a tragic event. Bob Sundler had a heart attack sitting at his desk one Friday afternoon. Although we quickly got him into nearby Hackney hospital, he died very shortly afterwards.

He had run the wool merchant business from Golden Square until it was moved to Wardour Street and closed. He then came to Chatham Place to take over as cloth buyer. Although he had worked for the company since 1929, he fell into the unfortunate category of older employees for whom Burberrys had made no pension provision. Being within a year from retirement, he was anxious to know what pension he could expect. We had made several requests on his behalf to GUS knowing that it would be as in all the other cases on an ex-gratia basis. The only reply we received was that he would have to wait until his actual retirement for a decision. He had been a close personal friend and had taught me everything I knew about textiles. It seemed callous treatment in return for his lifelong service. I was very much affected and wondered about my own future.

The immediate reaction from the management was not shock or sorrow at a sudden death, but 'Who is going to do the job now?'

I was asked to come up with an answer as soon as possible for a meeting at Leonard's office. I knew most of the people in Burberrys' area of business and I discreetly sounded out the fabric buyers at Daks and Aquascutum, believing they had the right experience to contribute. Leonard's only question was: 'How much do they earn?'

When I told him and said that this was the current rate for the job, he seemed shocked. He made it clear he had no intention of paying anything like that kind of money. He had a much better suggestion for me:

'You seem to know everything about this job. I want you to find a junior to do all the legwork. You can then just supervise him and tell him what to do.'

He was thinking of the comparatively simple job of buyer for the mail order catalogues. He had no understanding of what was involved in sourcing and managing the supply of specialized materials with a multi-million pound budget. Needless to say, there was no mention of any financial consideration for my additional responsibilities, but I was not surprised. It was all too obvious that I was working now for GUS and no longer for Burberrys.

I selected David Hall, the young trimmings buyer at Castleford. He adapted very quickly and the job became much easier after the computer system was installed at Chatham Place. The additional cost of travelling to and from London to work with me to learn the business plus hotel bills for his stay went quite a long way to eliminating the difference between David's salary and the salaries of the two London-based buyers I had suggested. However, David soon mastered the job and became a first-class buyer.

The publicity campaign in America was successful in its intended purpose. It also encouraged the company to open its first North American retail store in 1978 on East 57th Street, New York. It also led to approaches from a variety of mainly American companies seeking a license to utilise the rising interest in Burberry. Unsurprisingly, they all wanted to use the House Check with its strong identification making it all too easy to apply to the widest variety of products. The same reason made it easy for the production of cheap copies to devalue the company image. Nevertheless, great excitement was aroused. Soon a Director of Licensing was appointed and as the success of the company now seemed to be assured many felt secure enough to advance their proposals for the future.

Licensing meant a company could rent a label to exploit its area of business activity in return for royalty payments. The licensee must be of similar standing as the label and the product should be something a Burberry retail store might be expected to offer – Burberry toiletries and leather goods, yes; Burberry bedding and shortcake, no. It seemed this rule might not always be observed.

I preferred to stand back from the excitement. I believed there was a serious flaw in the licensing policy. A variety of companies marketing the label in their own various ways must inevitably lead to Burberrys losing the vital control of its own distribution policy.

A company I admired was Hermes. Its luxury leather goods and signature silk scarves illustrate perfectly how a brand evolves out of a product found to be the best of its kind. Hermes was for me an example worthy of study, but I had no doubt I would be alone in this thought.

18
EXODUS

PRIOR TO the changes in the board, I had been giving thought to the next phase of promoting the company. The Lichfield campaign had brought excellent results but it was time for something new. I had read in a magazine that the original Burberry de Havilland racing aeroplane was being restored to flying condition by the Shuttleworth Trust. I had enjoyed several of their flying displays of veteran aircraft and this was the same machine Burberry had sponsored for a record breaking flight from London to Cape Town in 1937. I wrote to them about some possible renewed sponsorship but other plans had already been agreed.

I had the germ of a new idea. The archives showed that Burberry had always offered a wide selection of active-wear. The Burberry Golfer and the Burberry Field Coat could become the next signature styles after the trench coat. With the high level of raincoat production it might be the time for one of the factories to be adapted for the manufacture of a new sportswear programme.

Sponsoring a sporting event such as golf or almost anything involving horses opened new publicity possibilities. I also thought it was time for a change from photography. The nineteen-sixties wave of young British fashion photographers had been exciting but seemed now to have settled into a formula. It might be an idea to revive the use of illustration artists with updated sporting print styling.

I was in the middle of these vague ideas when the boardroom changed. There was no point in meeting the advertising agency to work on a new campaign. The investment would be considerable but affordable and should take the company to a new level. But a company under a Chairman concerned about electric car windows was not the place for costly new proposals while the prospect of easy earnings through licensing was so attractive.

I was forty-five and had greatly enjoyed working for Burberrys over more than twenty years, but the thought of a further twenty years under GUS management was something I could not possibly consider. The odd combination of GUS and Burberry had always been a misalliance, but it would be years before Burberry was spun off into a separate company.

Rumour soon spreads in a relatively specialised field and I began to receive discreet soundings about my future intentions even before I had made any plans. The first was an invitation from Gerald Abrahams, the Chairman of Aquascutum, for an informal chat at his apartment in Grosvenor Square. He was very pleasant and I was struck by his close resemblance to Phil Silvers of 'Sergeant Bilko' fame. He had rather shrewdly asked me to bring my wife and said he would have a job for her if I decided to join

his company. She was enthusiastic but I felt little desire to return to corporate life. I was not entirely comfortable after more than twenty years with Burberry to begin promoting the advantages of the immediate close competitor, but it was a serious offer to consider.

After much thought I still felt that I really wished to work for myself. Both my father and grandfather had each owned their own businesses and had never been employees. I believed I could use my wide range of contacts at home and abroad to establish myself as an independent consultant. I had given a great deal of free advice over the years and, a little late in life, I had come to realize that advice can also be a tradeable commodity.

A casual conversation with a Japanese friend in London developed into a suggestion that a Japanese textile and clothing manufacturer would be interested in my services if ever I became free. While I was thinking about this unexpected approach from a country I had never visited, I had a call from an even more unlikely quarter. A Leeds clothing manufacturer known to me as a small but regular contractor for Burberry raincoats in one part of their family-owned business asked to meet me. Normally I had no personal contact with contractors who were dealt with by the production planning department.

Out of curiosity I agreed to meet with the head of Executex, John Luper. He said they wanted to move out of the uncertain contractor business and convert it to a more profitable full trading company, which they could control. They needed someone to help set it up and wondered if I knew anyone. John went on to say that if by any chance I might be interested, they would pay a fee equal to my Burberry salary plus half of any profits and I would be free

to pursue other interests. The offer seemed attractive and came at just the right time.

I could not set up a new business while still employed by Burberry. I needed to be free and so wrote a short letter of resignation to Stanley. It was abrupt but I had no wish to discuss my future intentions. The immediate reaction was a call to see Leonard. Rather than asking me why I wished to leave, he gave me a friendly and rather head-masterly lecture on his business philosophy. He said he considered me as something of an artist, which from him I took as a backhanded compliment.

His view of Burberry was that most of all he liked licensing as an infinite return on capital. Secondly he liked the retail stores since they were a cash business. Thirdly and very much last came manufacturing, which he did not like at all. It absorbed far too much capital and trade unions would always be a problem. With any need for merchandise, a queue of suppliers would be waiting at the door. He offered no inducement to stay, which I could understand since he had given the clearest explanation that the part of the business for which I was responsible was of no interest to him. It was a concise and sadly all too common view of the financiers in the City of London, leaving British manufacturing to continue its long decline. In 1958 when I joined Burberrys half of the working popu-lation was in some form of manufacturing. Today, manu-facturing accounts for only about 12 per cent of GDP, with employment having moved into the service industries and the public sector.

In fairness, I could not deny that at this time in the 'seventies, the unions were causing serious problems for much of industry, most notably at British Leyland. In later

years it was instructive to see how the failed British motor industry went on to attract investment and achieve great success once British ownership was exchanged for mainly Japanese and German control. It was still the same unions, but they were now making very much better cars.

With no further discussion, an indication that my departure might not be entirely pleasant came when I was presented with a list of six companies I should not join with a hint that my refusal to sign might affect my severance terms. New laws for employee protection rights have been passed since those days but, with my other plans, I signed without comment. I was then informed that I would have to come in to the office for three months but play no part in the business.

The management canteen was closed to me and my lunch was served on a tray in my office, but I could continue to use the company car. Needless to say, my attendance was more than sporadic. I would have been quite happy to be fired and free to get on with other things, but this shabby spectacle reflected no credit on the company and I was eventually released early. But that was not the end.

As soon as I was free to do so, I began to plan a new company for Executex.

It needed a trading name and I suggested London Club. It would call for not more than half a dozen styles and I selected fabric suppliers. I worked out a budget for a relatively small business and the cost structure was simple since Executex already had warehouse and office facilities. I would be the main overhead cost at the start up and

although the production was not large, the costings indicated attractive prices. The plan was to supply merchandise on a customer own label basis, for which there were enough interested buyers. Once the company was up and running, I would move on and act only in an advisory position. Executex was then well able to run such a simple operation.

As soon as trading began, Executex were served notice of a Court action by Burberrys applying for an injunction to terminate the business. The reason was not breach of any copyright but a claim that my long association with Burberrys would constitute the 'passing off' of any products devised by me. I had never heard of the term but would hardly be so naïve as to market obvious Burberry copies. Such an action could indirectly prevent me from making my living and although the injunction was against Executex, it was clearly aimed at me.

To help oppose the injunction on Executex, I appeared in court as a witness on their behalf. My lawyer, Walter Houser, presented a statement that although Executex and I had both been separately associated with Burberrys, their action was a clear attempt to restrict my ability to work. On the night before my court appearance, my home telephone became out of order as if a caller had forgotten to replace the receiver, but it was back on next day. Probably just a coincidence.

Burberrys issued a press release, which appeared in the *Daily Telegraph* and focused very much on my part. Then the case was suddenly dropped. Burberrys reached an out of court settlement with Executex by offering them as much contract work as they could handle on the condition that they terminate their association with me. Executex

accepted and I thought it was the sensible thing for them to do.

During the course of these events, I had been looking for a good retail and office location to start a new business venture. Meanwhile, I was using a temporary office near Harrods rented on a weekly basis. There were several similar offices on the same floor and I struck up an acquaintance with the occupant of the office next to mine. He told me he was intending to produce a film in America and was negotiating the sale of a script he had commissioned. In return I told him about my own legal problems for which he showed great sympathy. To my surprise, he pressed into my hand an object, which I recognized as a 9mm bullet.

'Here Brian. Take this to remind you. If somebody is causing you bother, I can always arrange to have them given a good spanking.'

'A good spanking' is what the police call GBH – Grievous Bodily Harm.

My neighbour's name was Charlie Kray.

One day, I noticed three very tall men coming down the corridor to enter Charlie's office. They all wore identical long black overcoats and I detected an American accent. There was a low hum of conversation from next door and the three men soon departed. Charlie quietly left shortly afterwards and I never saw him again. I heard that he was selling the story of his brothers, the notorious Kray twins both serving life sentences in prison for murder. There had been a dispute about the ownership of the film rights to their story. It must have been settled since a film was eventually made in 1990. Charlie died in 2000 aged 73 while serving a twelve-year prison sentence for drug

offences. His son-in-law and grandson were sentenced to life after a sensational murder in 2009.

While I was thinking Charlie's offer of settling disputes was not without a certain attraction during my legal involvement, I was contacted by another intriguing character. Joe Kagan, a.k.a. Lord Kagan, wanted to meet and invited me to lunch at the House of Lords. I was curious, so we made a date and he sent a car to pick me up from my new office in Beauchamp Place.

For me, Kagan was a figure out of the nineteen-sixties when he had been a close associate of Prime Minister Harold Wilson and a generous financial donor to the Labour Party. After surviving the war in his native Lithuania, he came to England in 1951 and developed a new fabric by bonding wool as a lining with a nylon outer to make a waterproof material. It was known as Gannex and the raincoats were produced in his West Yorkshire factory close to Wilson's constituency. The Prime Minister wore his Gannex on every possible occasion and made it famous. Kagan received a knighthood followed by a peerage in 1970. I knew he had been convicted of the misappropriation of company funds and had recently completed a ten-month prison sentence. I felt my acquaintance with Charlie Kray should be sufficient preparation for any eventuality.

After being dropped off at the House of Lords at noon, an attendant led me upstairs to meet Lord Kagan in the bar. He was quite small, alert and engaging.

He told me as soon as we were settled with our drinks:

'I'm sure you must know I've had a few recent difficulties. They took away my knighthood, but they can't do that with a Lord, so I don't really care.'

The bar began to fill up and new arrivals, including some well-known faces, came over to pat Joe on the back and congratulate him on his return. The bar soon became very full and it was evident that party politics played little part in what seemed an efficient Lords labour exchange for positions on government committees and other business opportunities. Worthy of a scene from Hogarth.

We went to take our seats in the restaurant. He happily told me: 'Thanks to the taxpayers, this is the finest value restaurant in London.'

After a glance at the prices on the excellent menu, I could do no more than agree.

And so to business. Could Gannex be revived? I thought it had disappeared but it was still struggling in its final stage. Kagan was probably looking for one last chance proposal. He had seen the article in the *Daily Telegraph* and must have thought it was at least worth a (subsidised) lunch. Equally, I had to admit I had gone more out of personal curiosity rather than expecting a business proposal.

Gannex was an interesting concept, which had enjoyed great popular success in the 'sixties, but any mention immediately brought an image of Harold Wilson to mind. Margaret Thatcher was now Head Girl and history had not been kind to Wilson. It would be a difficult problem to overcome. Additionally, I was not very enthusiastic about the product and I doubted Kagan could raise the funds for a relaunch. His best hope would be to license the process and name, something he must already have considered. He had half-expected my reaction and we adjourned to his flat nearby for a drink and then parted on friendly terms. I liked him and found the meeting a new

and quite fascinating experience. In particular, I knew now that those listening to politicians promising reform of the House of Lords should prepare themselves for a very long wait.

19

POSTLUDE

I HAD survived an attempt to discredit my reputation
and make it difficult for me to find work. I believe
that this display of personal animosity could only
have been with the approval of Leonard Wolfson. If so, it
reflected little credit on him.

Happily, I benefited from the law of unintended
consequences.

Far from harming my career, the case acted as an adver-
tisement for my services. I went to Tokyo and concluded
a consultancy contract with a large textile and clothing
manufacturer who were also the licensee for Brooks Bros.
in Japan. They wanted me to open an office and tutor their
young executives who would be sent from time to time to
live in London. I made annual trips to work in Japan, a
country I grew to know well and enjoy.

I undertook work in Portugal and the USA. Then Daks
asked me to examine the Invertere Coat Company, which
they had owned for some years in Devon. It had been
allowed to become so heavily in debt that if it had been an
independent company it would have long been declared

bankrupt. They should have written off the debt long before, but rather than invest further funds, they decided to close it. The manager Harold Shaw and I then saw a way to revive part of it.

Finance was an issue and manufacturing is a word hardly guaranteed to bring a smile to the face of a banker. The property belonged to the Newton Abbot local authority who were planning to rent it out for a furniture warehouse. We then negotiated a deal to utilise the premises for a three-year rent-free period on the condition that we would preserve at least half the jobs – a politically popular initiative. Our main fabric supplier, whom I had known for a long time, gave us very generous credit terms and we were in business after Harold and I put our own money in.

It saved some jobs and we started a new company manufacturing duffel coats in a Crombie type cloth but dyed in unusual and exotic colours. I sold them on my yearly visits to the new contacts I had made in Japan. With leather and horn trim the coats were expensive but proved very popular with young, fashion-conscious Japanese women. We eventually sold the business and if we hardly made a fortune we had had a lot of fun and had saved a factory with special skills from closing down. It is always easier to close a skilled factory than start one up.

My wife and I opened in Beauchamp Place a shop and office usefully located next door to the fashionable San Lorenzo restaurant. It was called Old England and specialised in cashmere products where my contacts in the textile trade proved useful in finding small and unusual suppliers. We were successful for many years until rents eventually reached an uneconomical level. This changed

both the business mix and village character of the street, which had been its original attraction.

The court case against Executex was not a great PR success for Burberry. Colin Wilson, my able deputy who ran the operations at Chatham Place, left to join Aquascutum, as did Roy Lack the UK Retail Director. David Hall, the fabric buyer, also left to join a Portuguese textile manufacturer. They were probably my three closest Burberry colleagues and I had no further contact with the company for many years.

However, it was hard to avoid seeing the House Check in some unlikely places, especially after Burberry check baseball caps became the badge of the football hooligans known as 'chavs', seriously tarnishing the company image.

For the next twenty years, I made my career from a variety of sources, but I would never return to the corporate life. I had gained what I wanted most – freedom and independence. Burberry survived once again after new American management sought to return some class to the brand and after the severance from GUS, it has gone on to become one of Britain's most successful companies.

I am glad I had once played a part in it.

Appendix: Burberry, 1910-1940

B
Y NINETEEN-HUNDRED Burberry, founded in 1856, had good contacts within the War Office. Officers had a rubberised mackintosh raincoat, which although waterproof, was also airtight causing interior condensation. In the South African climate during the Boer War the Burberry tightly woven lightweight cotton gabardine proved to be far superior since the fabric breathed. As a result, in 1906 the War Office approved the Walking style Burberry to be known as the **Infantry Pattern**. The same coat with a deep rear inverted pleat to be opened out when mounted was known as the **Cavalry Pattern**.

The Army had garrison duties throughout the British Empire where the climate was usually hot. Senior officers soon requested a cotton gabardine coat in the same double-breasted style as their woollen greatcoat and Burberry produced the **Tielocken**. Its success was assured when Field Marshal Lord Kitchener, head of the Army, adopted the style. The Admiralty approved the Infantry Pattern for naval officers and the Tielocken, but with

buttoning front. Both were in Burella, a Burberry shower-proofed navy blue wool gabardine.

For the Army, Burberry developed Regulation Khaki, also a cotton gabardine, by weaving a mixture of green, brown and yellow proofed yarns to reproduce the exact khaki colour of military woollen fabrics.

With the advent of trench warfare by 1915, the Tielocken pattern was used in the design of the full Trench Warm. The detachable sleeved liner in camel fleece could usefully double as a dressing gown for those senior staff officers comfortably billeted well behind the front line and who were probably the main customers for this expensive item.

As with all other suppliers to the government, the war had brought great commercial success to Burberry, who were reported to have produced almost five hundred thousand coats for the armed forces. The military Trench coat fell completely out of favour with the end of the war. However, the Tielocken style often appeared, except with front buttoning, as the **D.B. Belted Burberry**. Hitler was often photographed electioneering while wearing a German version of this style until he abandoned both coat and elections to don the Nazi uniform.

The Infantry Pattern, having been worn by the more numerous junior officer ranks, was by far the most common Burberry with the army. After the war it was known as the **Walking Burberry Style 1**. It was offered in every fabric from a featherweight poplin as a Duster motoring coat, to heavy Winter weight tweeds from Ireland and Scotland for topcoats.

The basis of all Burberry raglan models was the easy fitting one-piece sleeve construction eliminating the over shoulder seam. Side pocket welts with button closing

gave access to a roomy bucket type internal pocket often referred to as the 'poacher'. The Army Cavalry Pattern entered civilian life as the **Burberry Riding Coat** and the Walking style was made with an underarm gusset seam known as a pivot sleeve. It allowed the arm to be raised without lifting the whole coat. It was the distinguishing feature of the **Shooting Burberry**.

The same approach was applied to womenswear, as in the Walking and Riding styles for women. The men's D.B. belted Burberry was successfully adapted for the female figure. It proved very popular and as usual it was offered in all of the company's cotton and woollen fabric collections.

These designs, sporty and practical, were new for women and far removed from the fussy Edwardian fashion of the pre-war years. The war had a great liberating effect on women. They had driven ambulances on the front line and had taken over from the absent men in factory and office. Their taste in both clothes and hairstyles reflected women's new independent lifestyle and their increased self-confidence.

The liberating effect was most evident in the participation by women in the rapid expansion of sporting activities after the war. Burberry already provided for men in motoring, riding, shooting, golf, skiing, cycling and mountaineering.

The Burberry approach to sportswear design was determined by the practical purpose for which the garment is required. When successful, little future change should be necessary. Variety came once again from innovative fabric selection.

One example might be the three-quarter length Walking style worn by the early motorcycle rider around

1912. This coat became a general utility garment and featured in the collection for the next fifty years. It became known as the **Short Shooter** and was promoted in various guises as the **Car Coat**, the **Field Coat** and **Spectator Coat**. The changing roles were determined by the fabric selection: wool lined cotton gabardine: Whipcord: Covert and Harris tweed.

All the men's sportswear styles were adapted for women, making Burberry possibly the world's oldest producer of sportswear for both men and women. The practicality and strict design-for-purpose approach still give much of this early Burberry sportswear a contemporary look.

It is noteworthy that Burberry never offered a women's version of the full military Trench style. This would have to wait until the bolder nineteen-sixties but it then went on to far outsell the men's Trench to become a staple of every woman's wardrobe. Similarly, it is odd that the celebrated Burberry House Check was nowhere to be found in the old archives. Like the women's Trench, it too became a phenomenon of the nineteen-sixties.

For men, the Trench coat only returned to favour during World War Two. Humphrey Bogart's appearance in the 1941 film *Casablanca* may have been an influence, but the Trench was seen everywhere as part of the uniform of the thousands of American army officers arriving in England to prepare for D-Day. After the war, it went on to become the coat of choice in the film noir genre films of the nineteen-fifties and again in the spy films of the 'sixties. Still hugely popular in America, the Trench somehow fails to hit quite the right social note in Britain.

Postscript

S INCE THE completion of this book, the changes in Burberry top management announced in July 2016 call for comment following the company's long run of success, unique among British clothing manufacturers. This success can be largely attributed to the emerging economic strength of China providing up to 40 percent of Burberry's business. This imbalance leaves the company exposed. In a global economy tastes in fashion change quickly, and China today is not unlike Japan during the 1980s. That country has moved on to become one of the world's most sophisticated clothing and original designer markets, leaving Burberry and its House Check with a considerably reduced presence. Could a similar future soon await in China?

In the mature established markets of Europe, USA and Japan, the constant run after any and every new designer label – 'fame for fifteen minutes' – has already passed its peak. As consumers move to a policy of 'fewer but better', there can surely be no better time for the company to return to the original Burberry concept – manufacturing the very finest quality and most technically advanced

sports and all-weather wear in the world for the highest class international market.

I am indebted to Colin Wilson not only for the remarks in his Foreword, but also for expressing his views on the future of Burberry. It will come as no surprise to the reader that a former long-term company associate and I share those same views. Burberry is very important to the future of the British clothing industry with all its associated employment opportunities. The initiatives of the new incoming management are likely to be watched with close interest.

RDI

7 August 2018

Somerset